MIRAMICHI
seasons

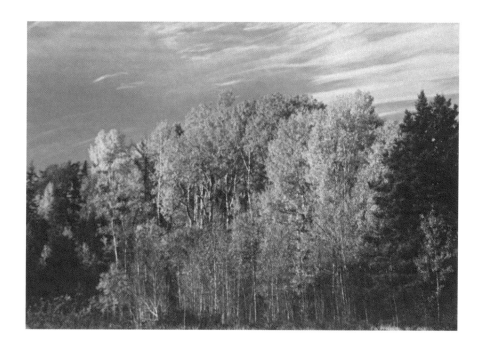

PHOTOGRAPHY BY CATHY CARNAHAN

FORMAC PUBLISHING COMPANY LIMITED

This book is dedicated to my family and friends, to the people who have shared the seasons of my life. How can I begin to name you all?

It is for my nieces and nephews: Andrew, Jane, Amanda, Terri Anne, Justin and Jordan. These are the special young people in my life who bring sunshine to every season.

It is a tribute to the Miramichi, to the people who live here, to those who have gone away, and to the visitors who come to celebrate in this unique land of ours.

Come join in the celebration. Enjoy Miramichi Seasons!

Formac Publishing Company Limited acknowledges the support of the Department of Canadian Heritage and the Nova Scotia Department of Education and Culture in the development of writing and publishing in Canada.

Canadian Cataloguing in Publication Data

Carnahan, Cathy, 1961–

 Miramichi seasons
 ISBN 0-88780-468-3

1. Miramichi River Valley (N.B.) — Pictorial works. I. Title.

FC2495.M48C37 1998 971.5'2104'0222 C98-950224-4
F1044.M5C37 1998

Formac Publishing Company Limited
5502 Atlantic Street,
Halifax, Nova Scotia,
B3H 1G4

Printed and bound in Canada

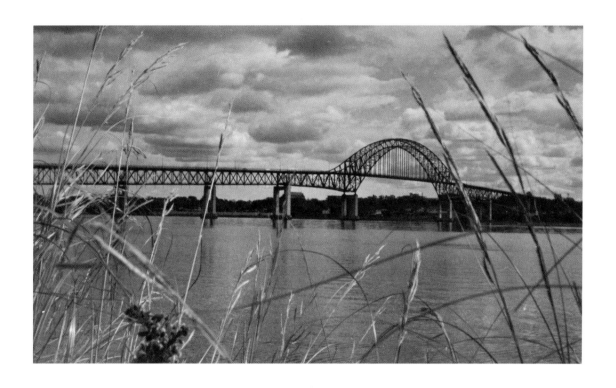

Contents

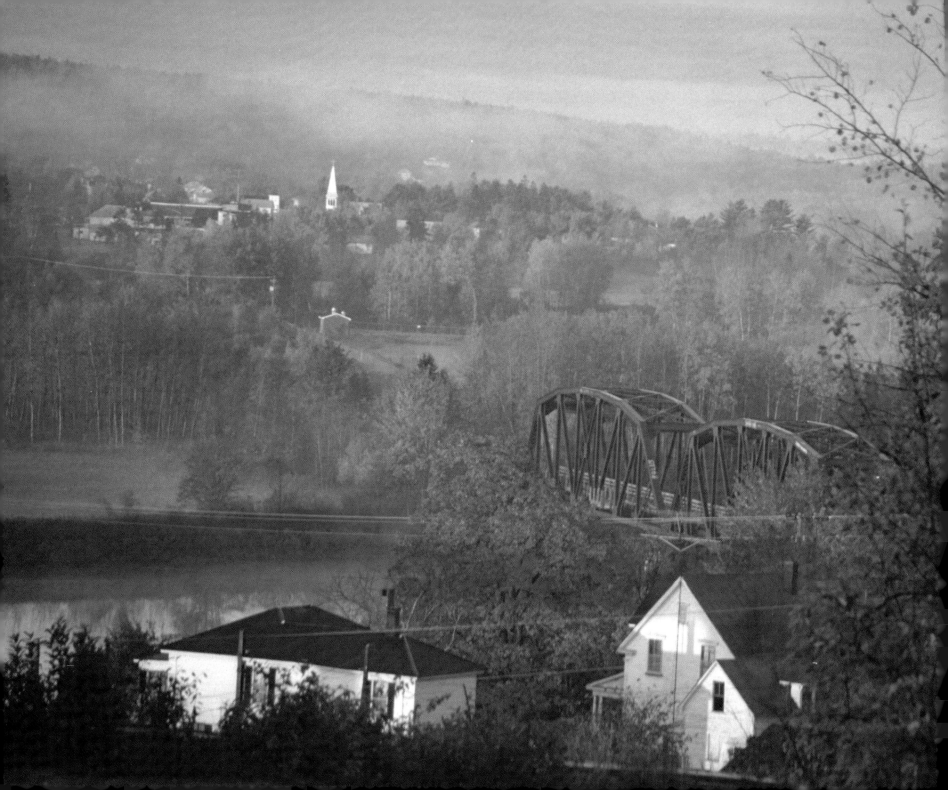

Introduction

To everything there is a season, and a time to every purpose under the heaven:

A time to be born, and a time to die; a time to plant, and a time to pluck up that which is planted;

A time to kill, and a time to heal; a time to break down, and a time to build up;

A time to weep, and a time to laugh; a time to mourn, and a time to dance;

A time to cast away stones, and a time to gather stones together; a time to embrace, and a time to refrain from embracing;

A time to get, and a time to lose; a time to keep, and a time to cast away;

A time to rend, and a time to sew; a time to keep silence, and a time to speak;

A time to love, and a time to hate; a time of war, and a time of peace.

Ecclesiastes 3: 1-8

Follow our river to adventure; here in the Miramichi!

Start the grand tour wherever you wish. Here in eastern New Brunswick, you will discover a unique region of unrivalled beauty enhanced by the mystical Miramichi River which flows through it. This is our piece of paradise.

This book is a reflection of the seasons in this special place we call home. Come celebrate with us!

The Miramichi region offers its residents and visitors a relaxing, memorable experience. In addition to magnificent scenery and abundant all-season recreational activities, there are numerous festivals and events. There is something for everyone's taste and budget.

The New Brunswick International Air Show, Canada Day festivities, Rock'n Roll Weekend and Golden Oldie Car Show kick off the first summer celebrations.

Colourful and intriguing powwows take place in the First Nations communities of Eel Ground, Red Bank and Burnt Church. Each of the events has its own charm and distinctiveness reflecting the unique communities in which they are hosted.

Festival Fruits-des-Mers in Baie Sainte-Anne pays special tribute to citizens in fishing communities along Miramichi Bay. Watching boats return to Escuminac Wharf at sunset is a breathtaking sight.

Canada's Irish Festival on the Miramichi welcomes everyone to a giant bash the third weekend in July. Keep a watchful eye for little green leprechauns as they sing, dance and celebrate their Irish heritage at parties, concerts, parades and church masses.

The annual Bay du Vin Summer Survival also has many highlights, including entertaining frog races.

New Brunswick Day on Aug. 3 pays tribute to this great province of ours. Look for picnics, concerts and events throughout the Miramichi region as we celebrate with our provincial counterparts.

Then there's the annual Miramichi Folksong Festival featuring multicultural, authentic and contemporary folk music in English, French and Mi'kmaq.

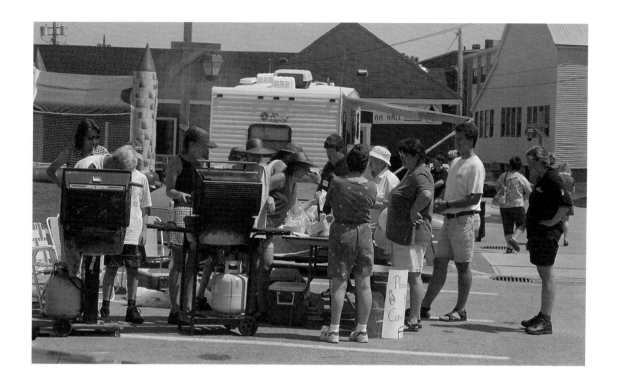

Friends, neighbours and visitors all gather at the Napan Agricultural Show and the Miramichi Agricultural Exhibition, with livestock, produce, arts and crafts at their best, and lots of entertainment.

Costumed guides at the MacDonald Farm Historic Site in Bartibog welcome visitors and tell the riveting story of 1820 Scottish entrepreneur Alexander MacDonald.

Enclosure Park, with its campground, picnic area, archaeological display and historical cemetery, is enclosed on three sides by the grand Miramichi River. It was once home to Mi'kmaq, Acadian, Scottish and British Loyalists.

The City of Miramichi combines the modern amenities of larger urban centres with the hospitality and proud history of a smaller municipality. It offers parks, historical buildings and many festivals.

Rogersville features the Acadian National Monument. This community is home to well known religious orders — the Trappists and the Trappistines. The Rogersville Brussels Sprouts Festival is in late July; Acadian Day celebrations are on August 15.

Nature, white sandy beaches, and refreshing saltwater are the features of Kouchibouguac National Park. It's only 40 minutes from the City of Miramichi and a perfect day trip.

Route 108 follows the river to Upper Miramichi where visitors can enjoy the educational Atlantic Salmon Museum in Doaktown. The Doak Historic Site on Main Street explains how Doaktown got its name.

To step back in time and savour the atmosphere of an old time lumbering camp, there's nothing to equal the Central New Brunswick Woodmen's Museum in Boiestown, the geographical centre of the province.

There is much to see and do in the land of Miramichi, but if you want to just sit back and revel in its tranquil beauty that is completely understandable. Take a stroll through the area, relax, and enjoy a special piece of the universe.

Map of the Miramichi

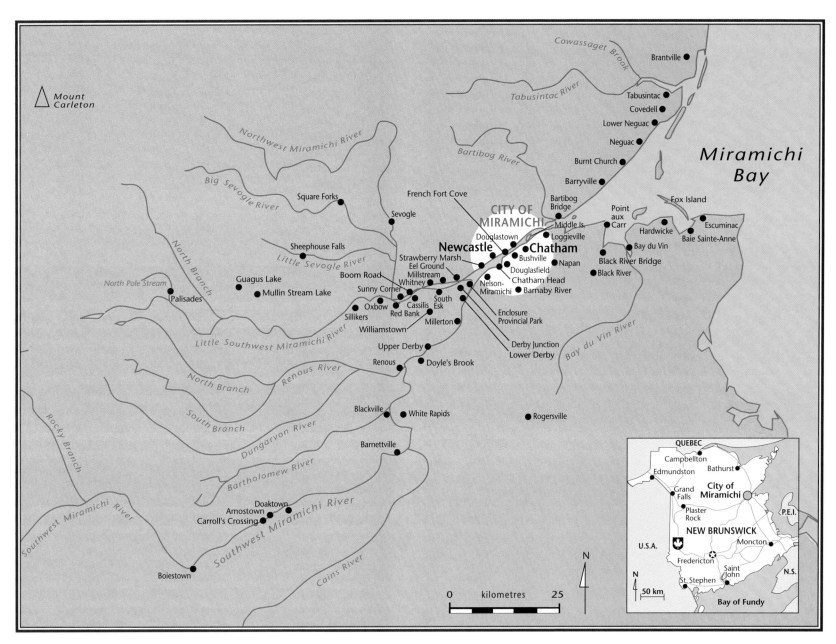

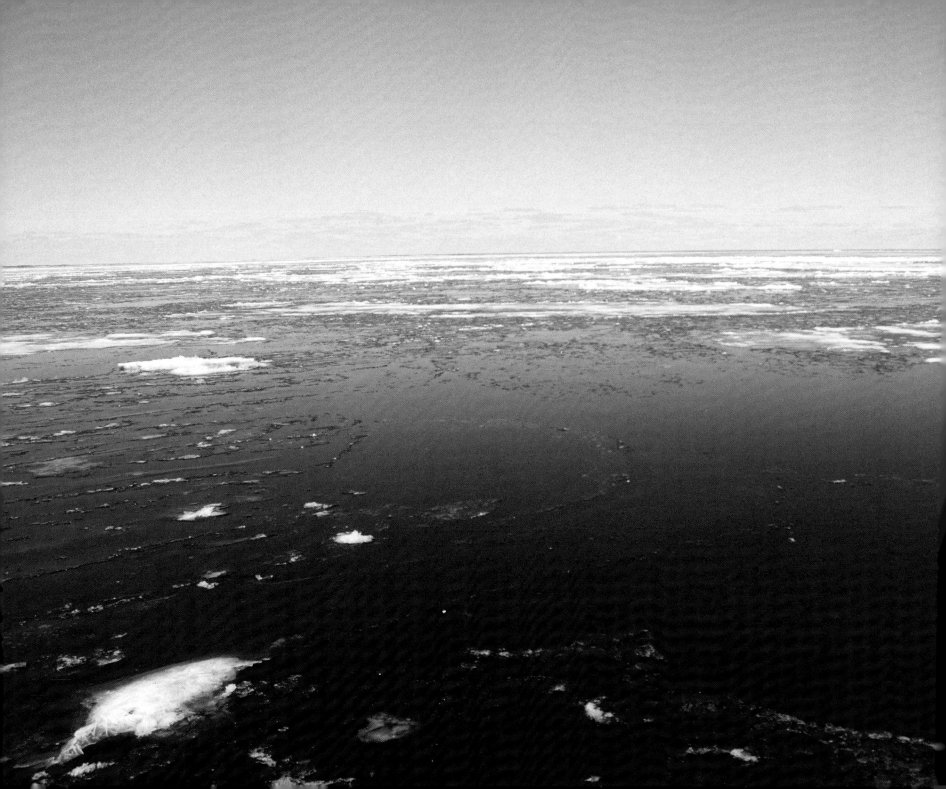

Spring

Spring has arrived! Ice in the mighty Miramichi vanishes. Black salmon return to the region and the

river welcomes people in rubber suits, casting their lines, seeking their fortune. Canada Geese honk

overhead, celebrating their arrival. Feel the soft, warm breeze. Hear gentle rains sprinkling on the roof.

Watch the flowers and trees bud. The earth is awakening. The days are becoming longer, warmer.

Watch as Mother Nature transforms our home on the shores to brilliant shades of the rainbow.

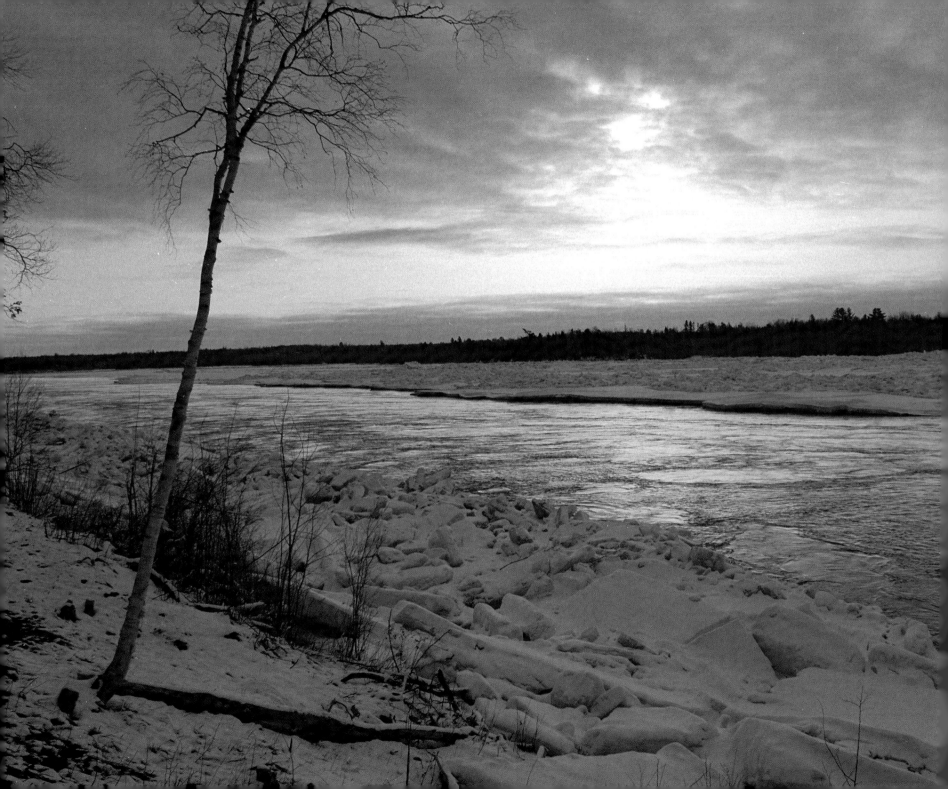

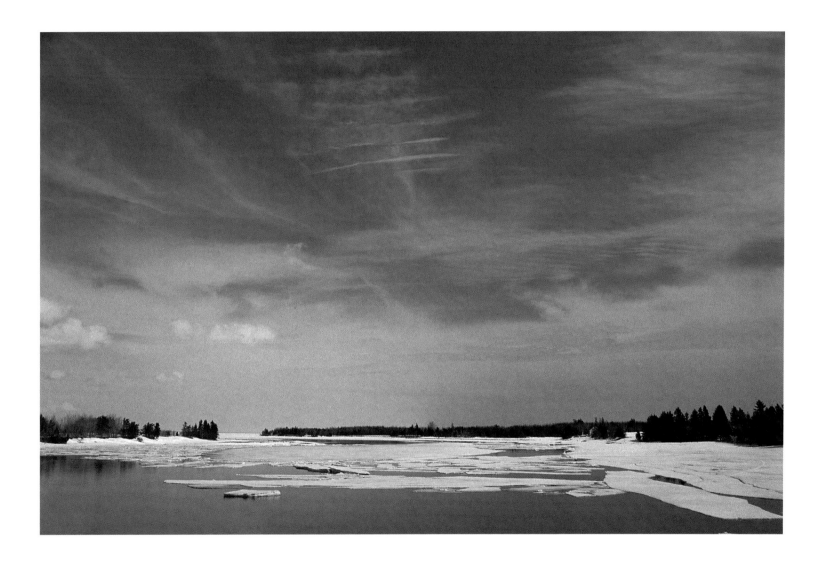

Bay du Vin (above) and spring breakup in Millerton (opposite).

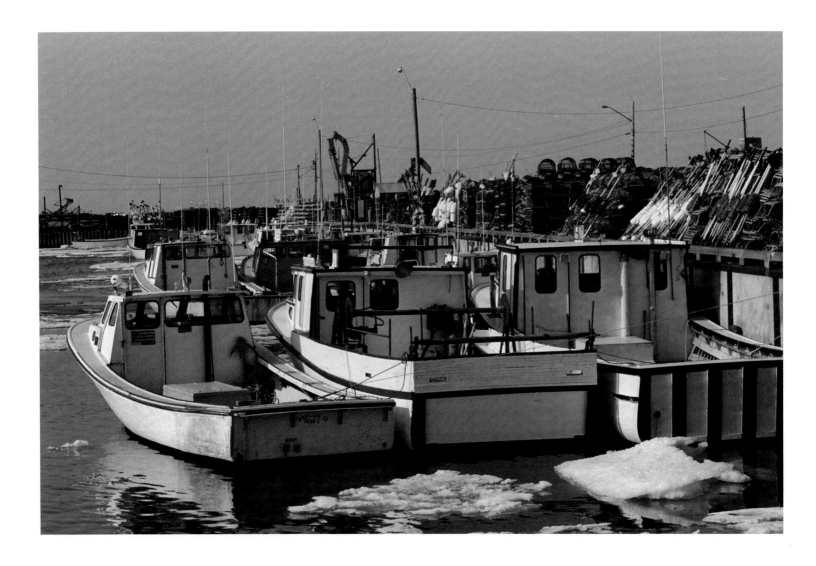

Lobster fishing boats at Escuminac wharf.

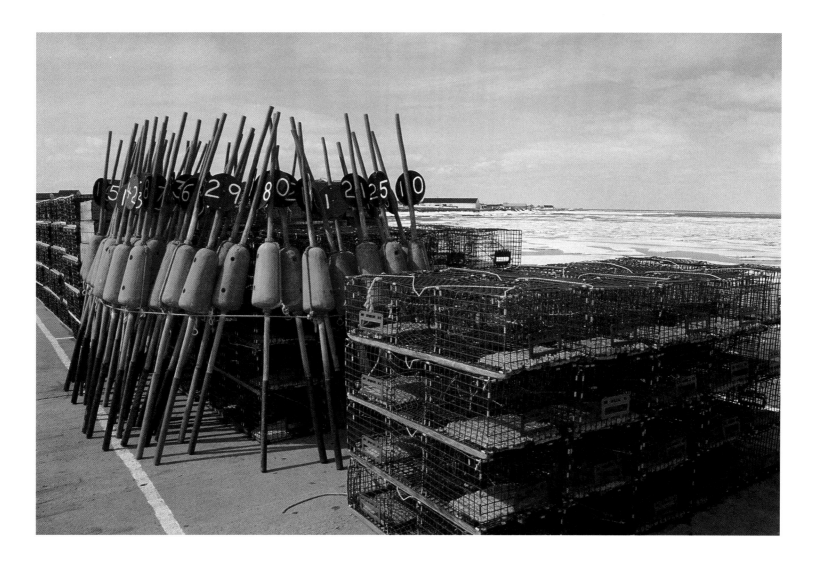

Lobster gear ready to be set.

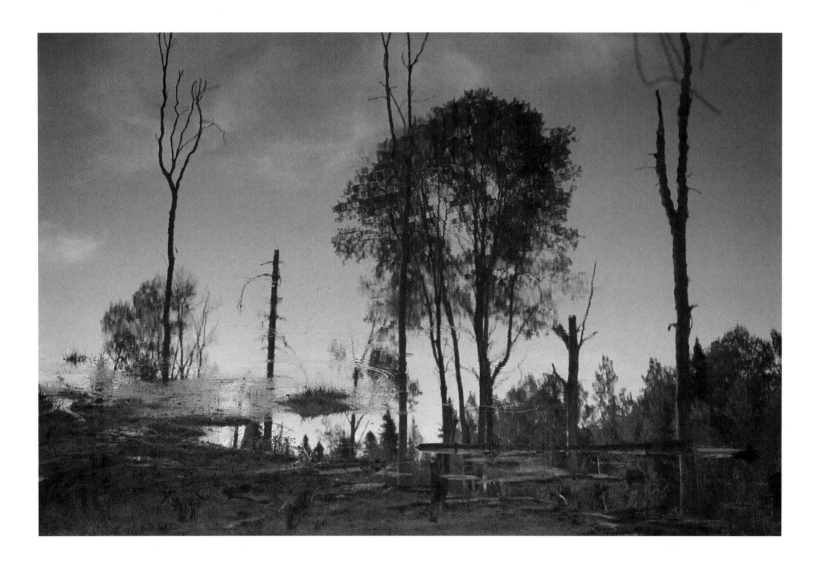

Mullin Stream pond.

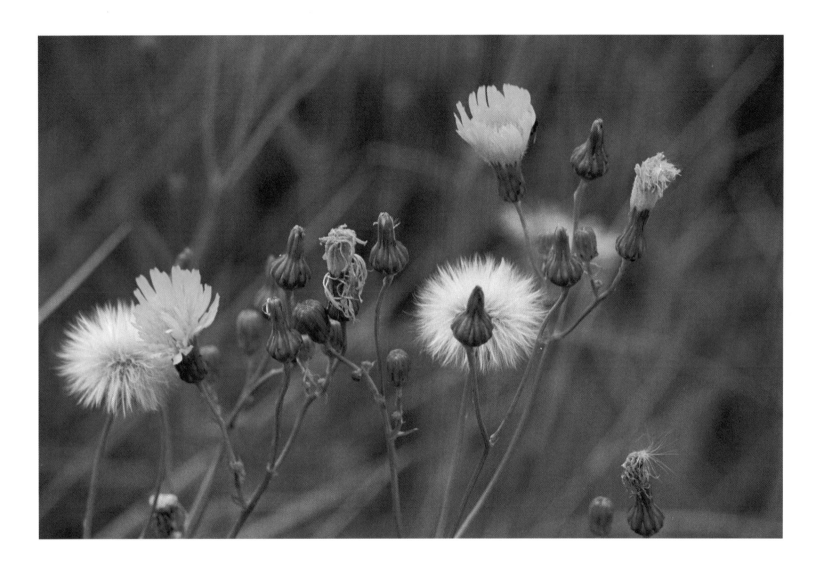

Millerton.

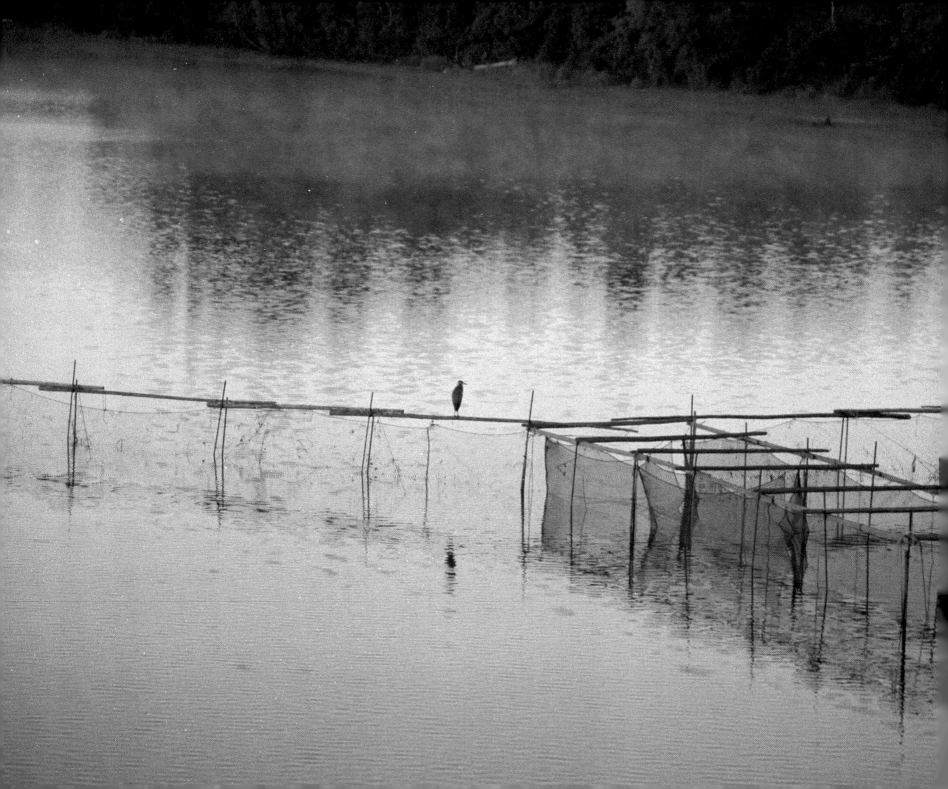

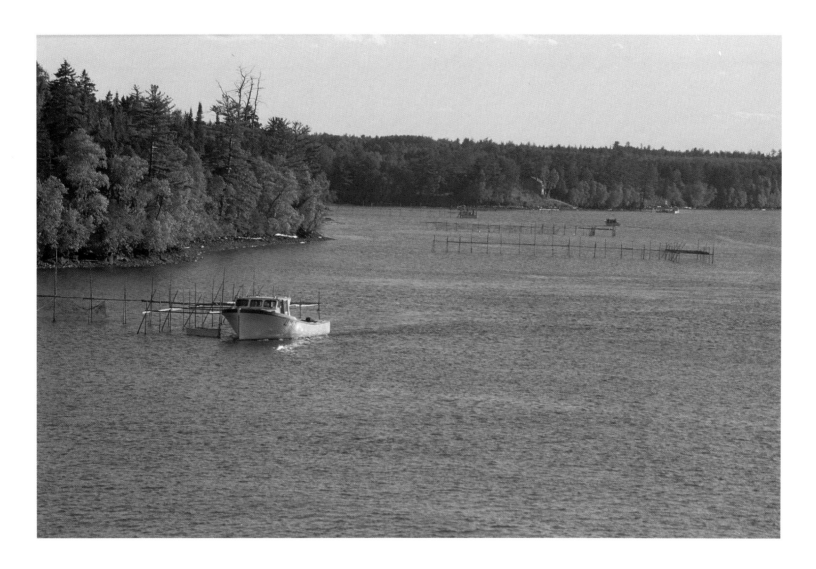

Gaspereau fishing on the Northwest Miramichi (above); an osprey at Red Bank (opposite).

A beaver pond at Mullin Stream (above and opposite).

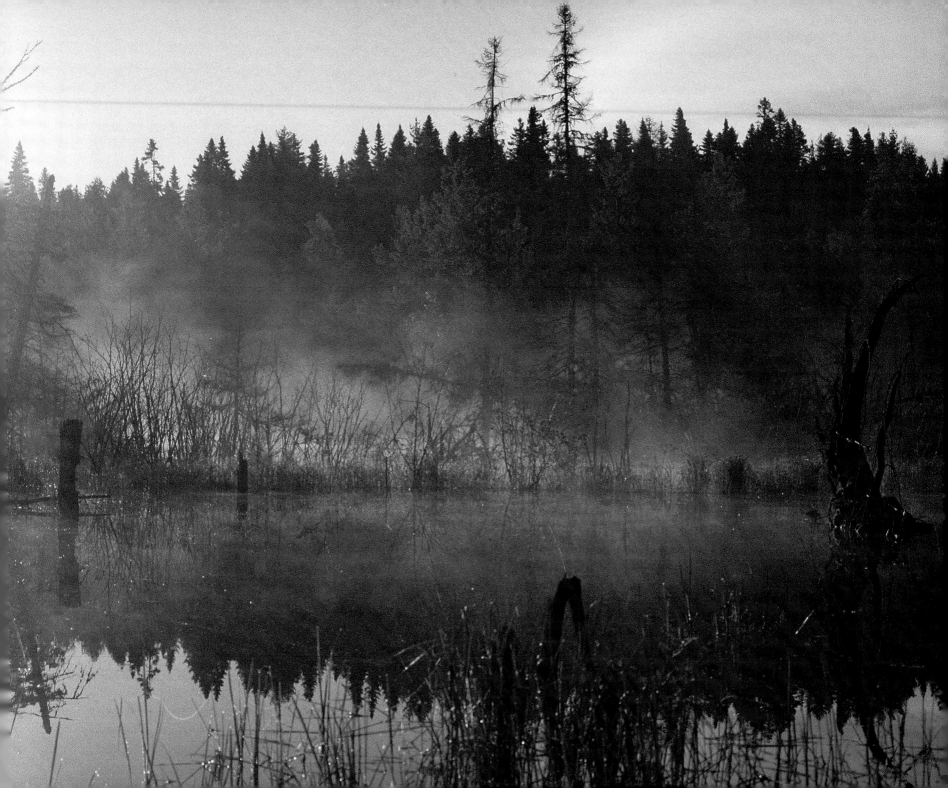

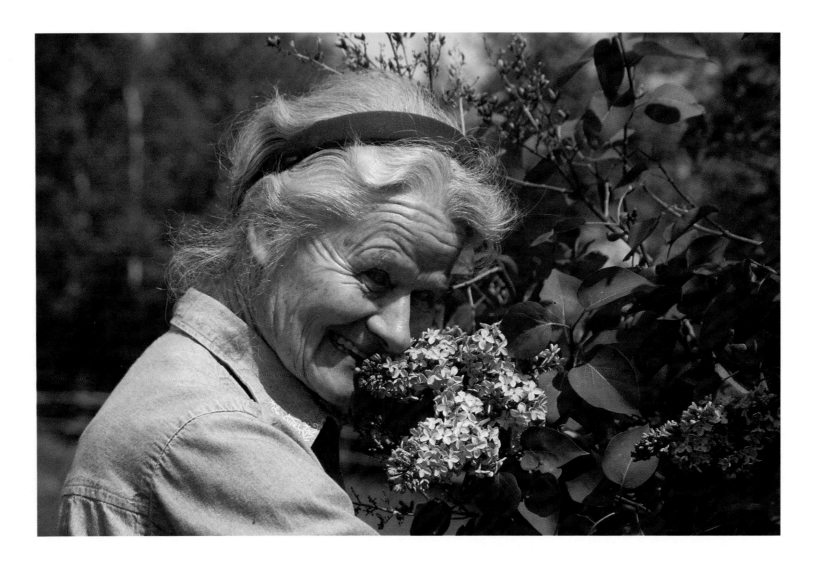

Marianne Weber of North Black River Road with her lilacs.

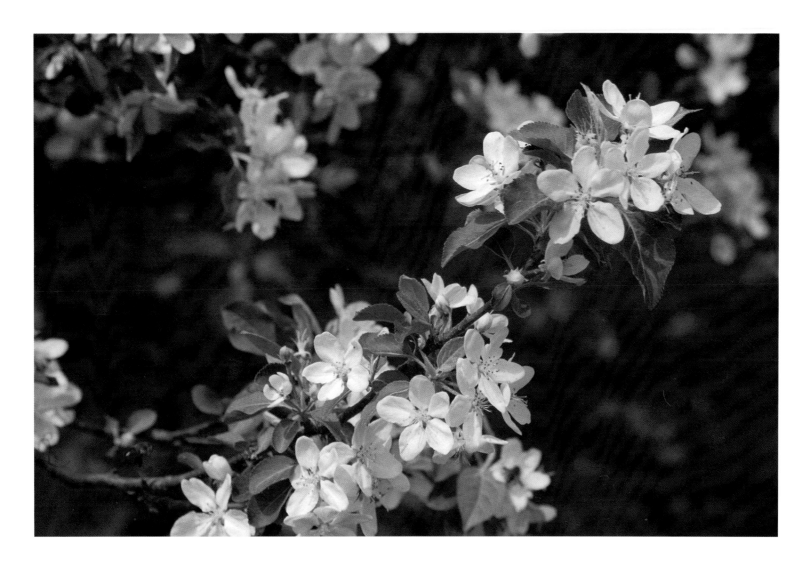

Apple blossoms in Williamstown.

Bay du Vin (above) and Nelson-Miramichi sunset (opposite).

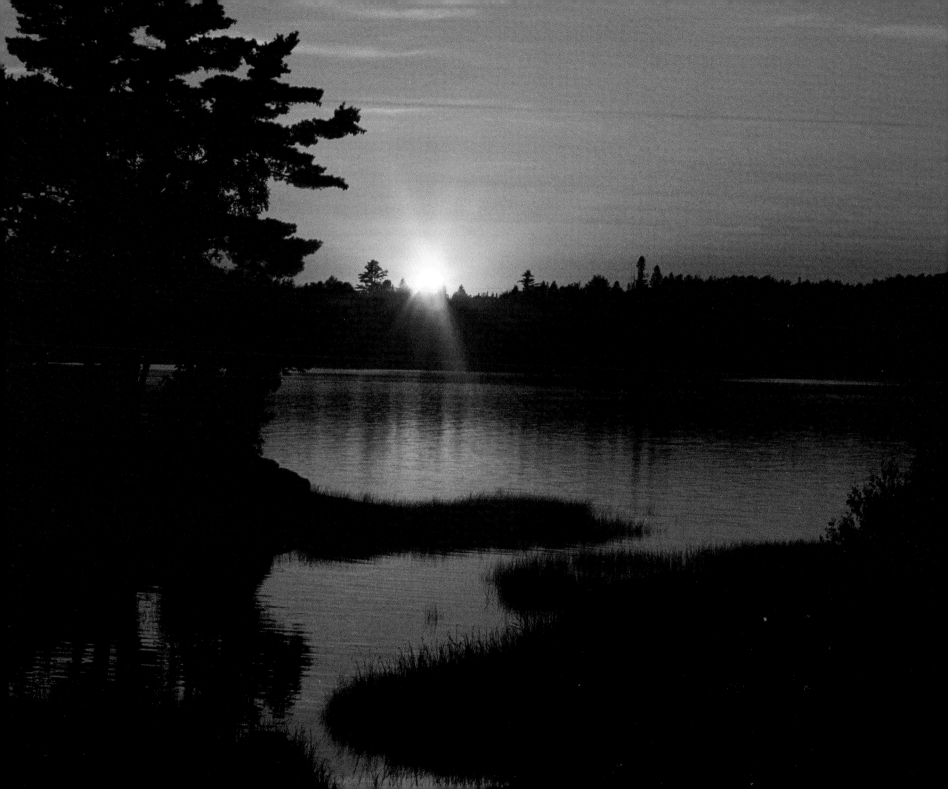

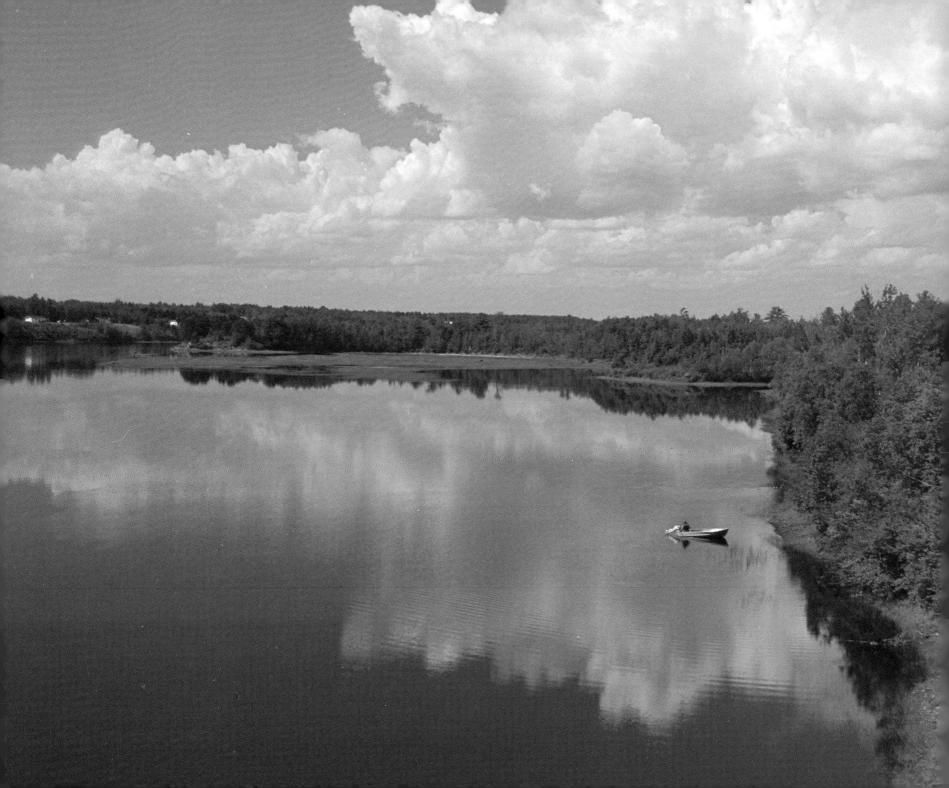

Summer

Welcome to Summer! Hot sunny days and warm nights greet you in Miramichi during this season of

celebrations. Hear birds and crickets sing. Listen to children giggle as they delight in summer treats.

Watch the lawn grow. Smell the sweet scent of flowers and hay. Attend a festival, concert or

special event. Summer activities abound in this magical land. Make every day count;

make no assumption the season will last for it is truly short, sweet and scrumptious.

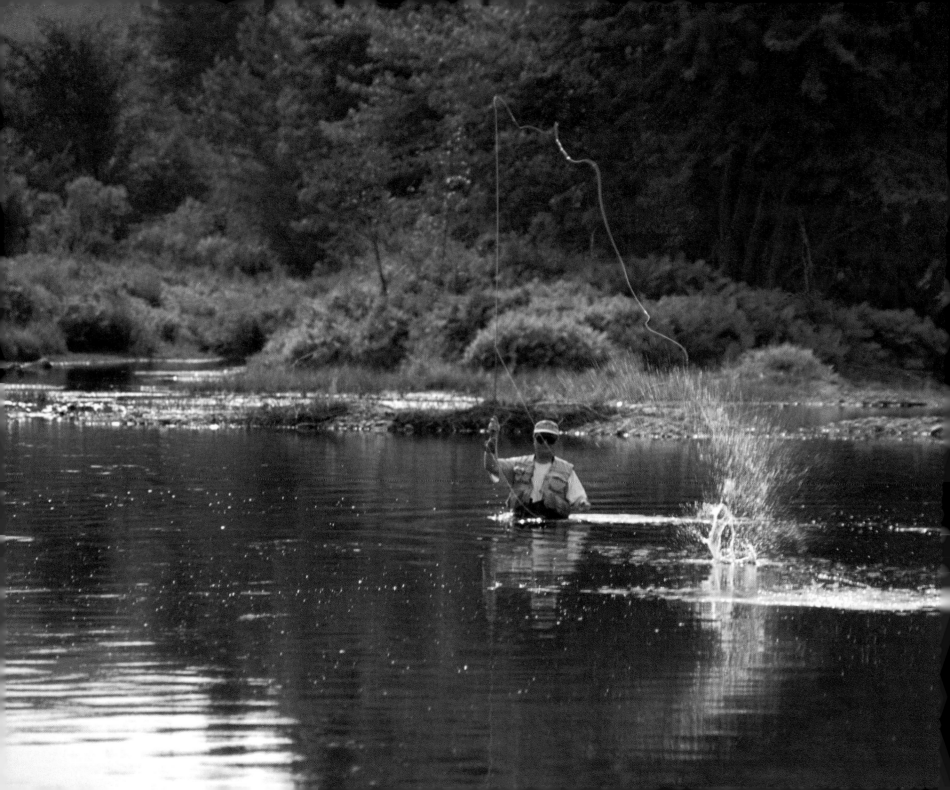

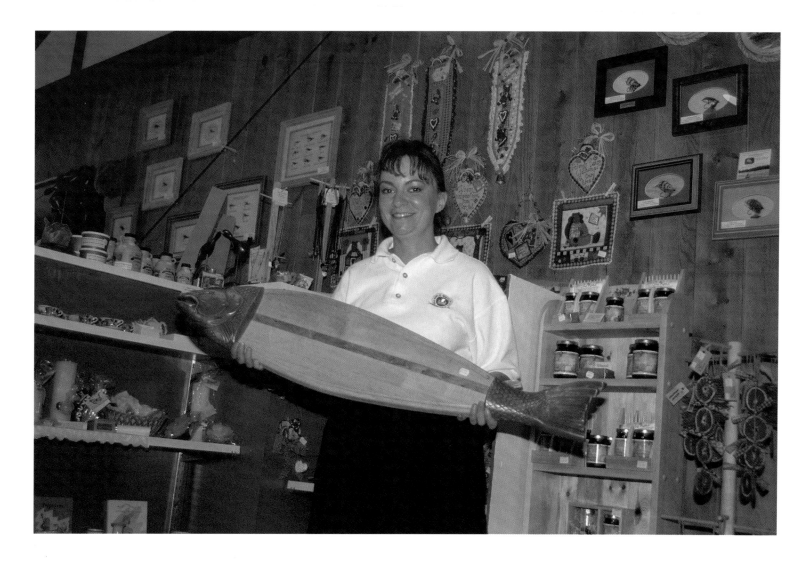

*Carla Black at the Atlantic Salmon Museum gift shop in Doaktown (above); Stephen Cail of Fredericton fishing at
Little Island Pool in Amostown (opposite).*

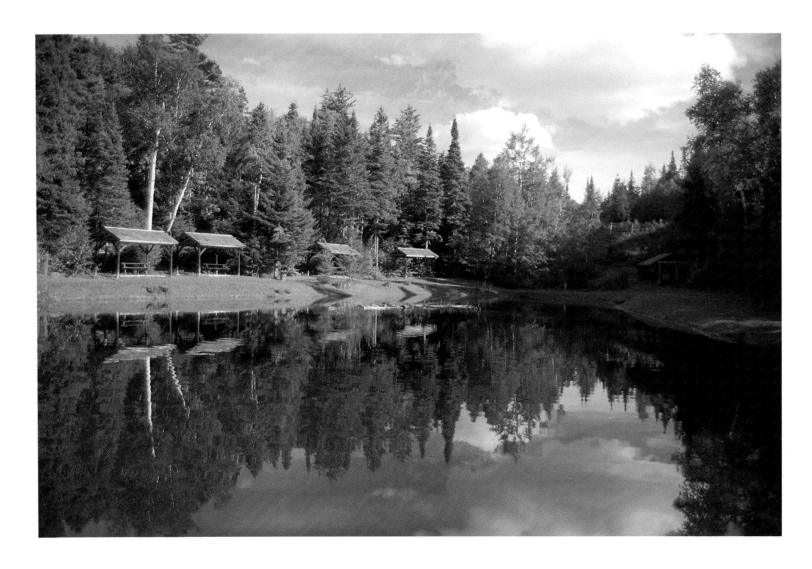

Central New Brunswick Woodmen's Museum in Boiestown. Woodland trails, a trapper's cabin, museum, lumber camp kitchen and bunk house are favourites here (above); evening sunset on the Northwest Miramichi overlooking Eel Ground First Nation (opposite).

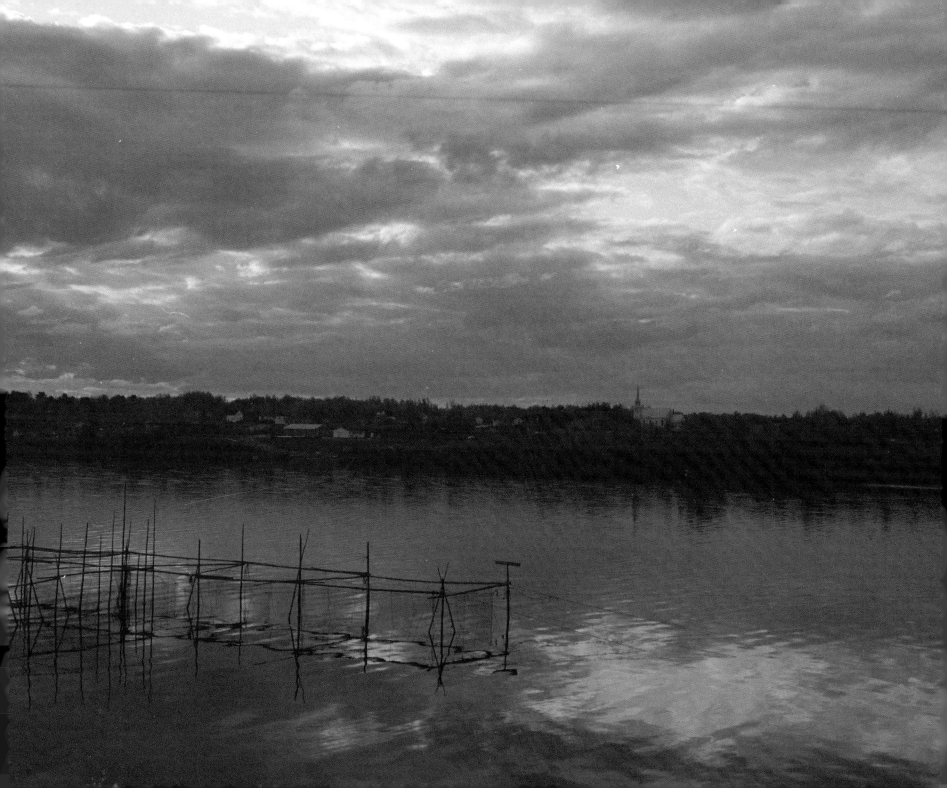

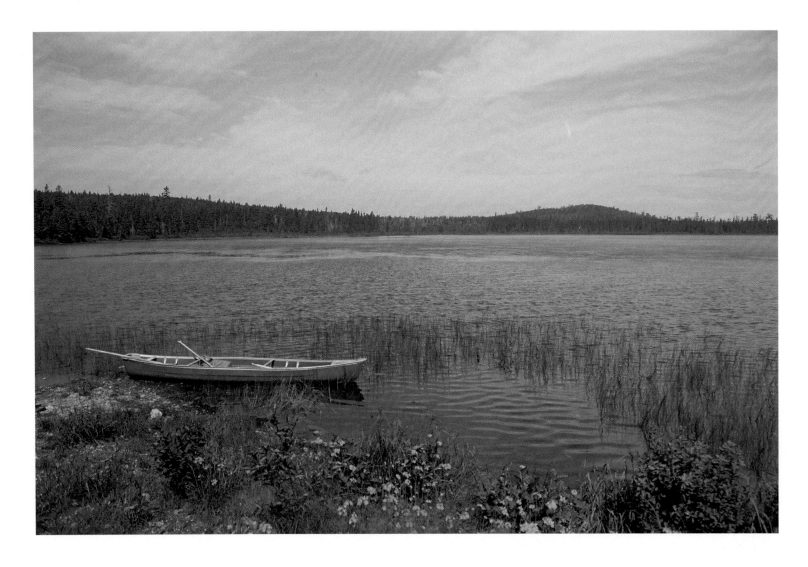

Guagus Lake (above); Andy Carruthers of Cassilis canoeing at Guagus Lake (opposite).

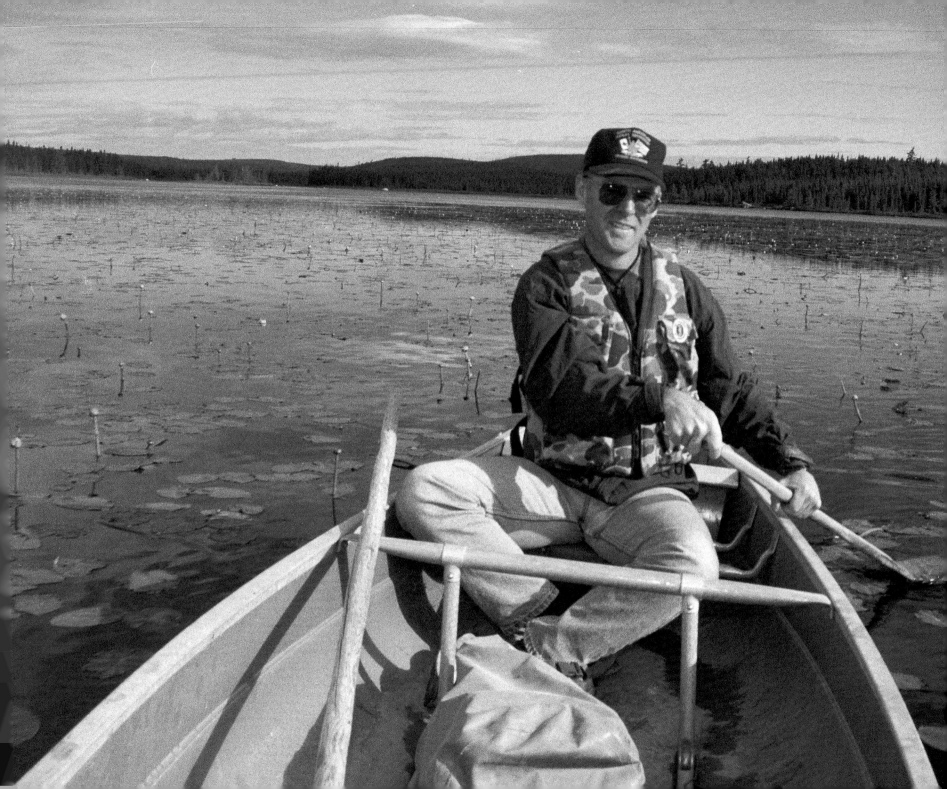

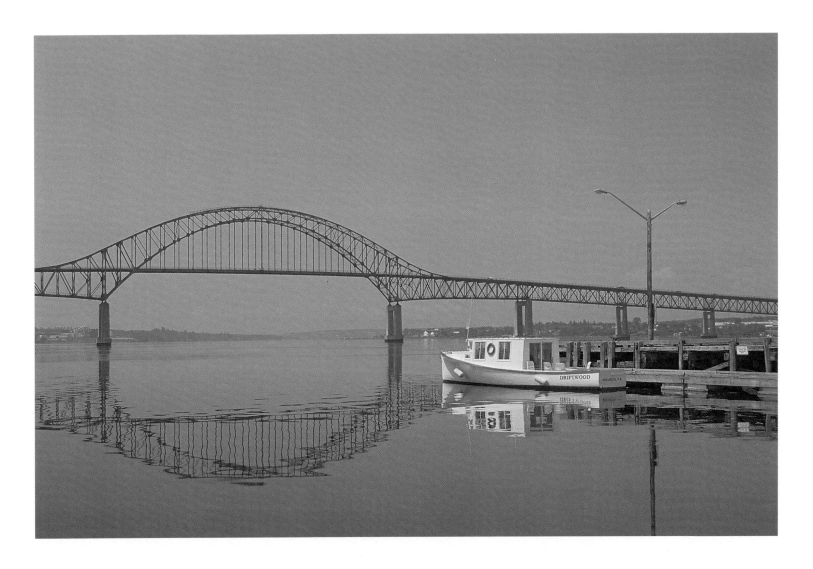

Centennial Bridge from Station Wharf in Miramichi East (Chatham).

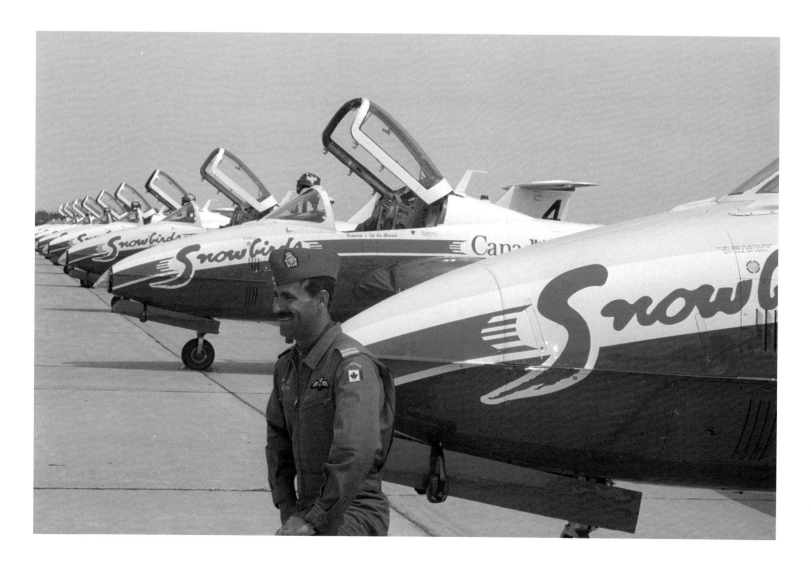

The Canadian Snowbirds are always a favourite at the New Brunswick International Air Show. Here, Snowbird
Rod Ermen of Moncton poses for Miramichi fans.

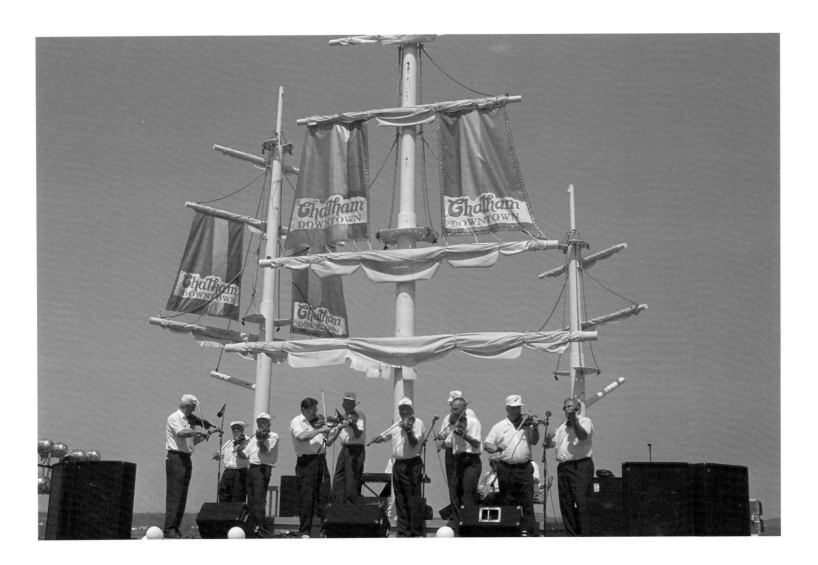

The Miramichi Fiddlers performing in the Waterstreet Business District at Chatham.

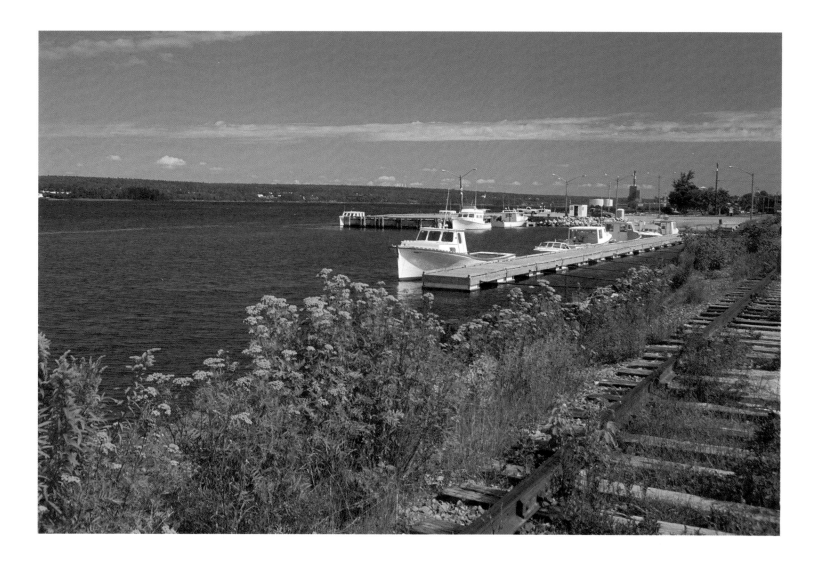

Station Wharf in Miramichi East (Chatham).

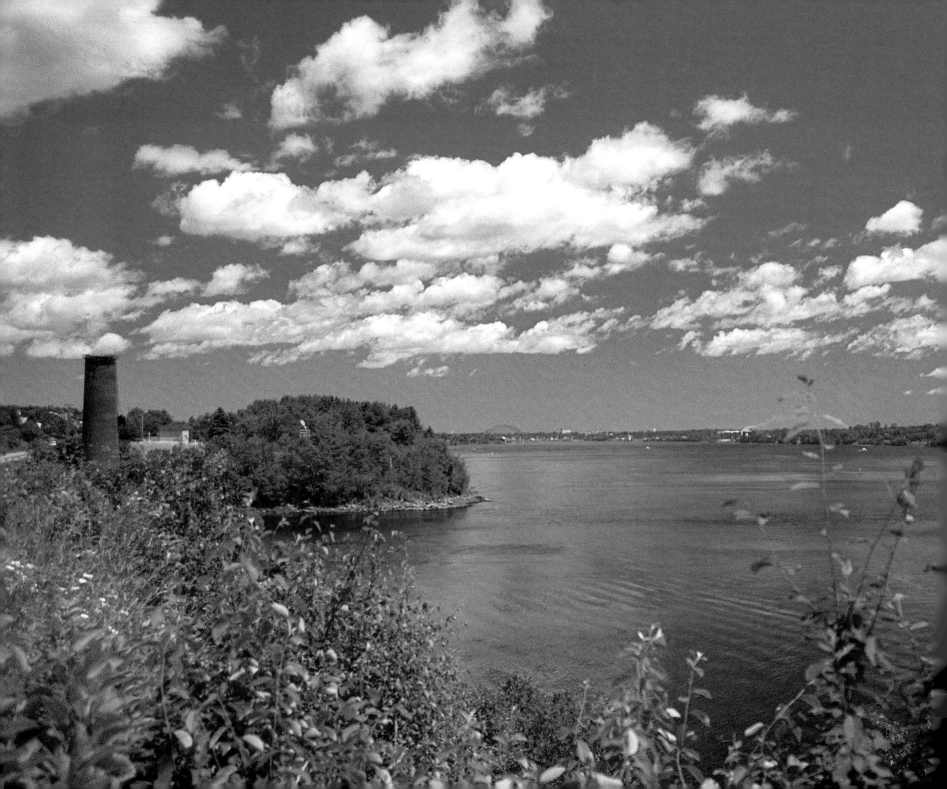

Bridgeview Plaza at Douglastown overlooking the Miramichi (above); French Fort Cove (opposite).

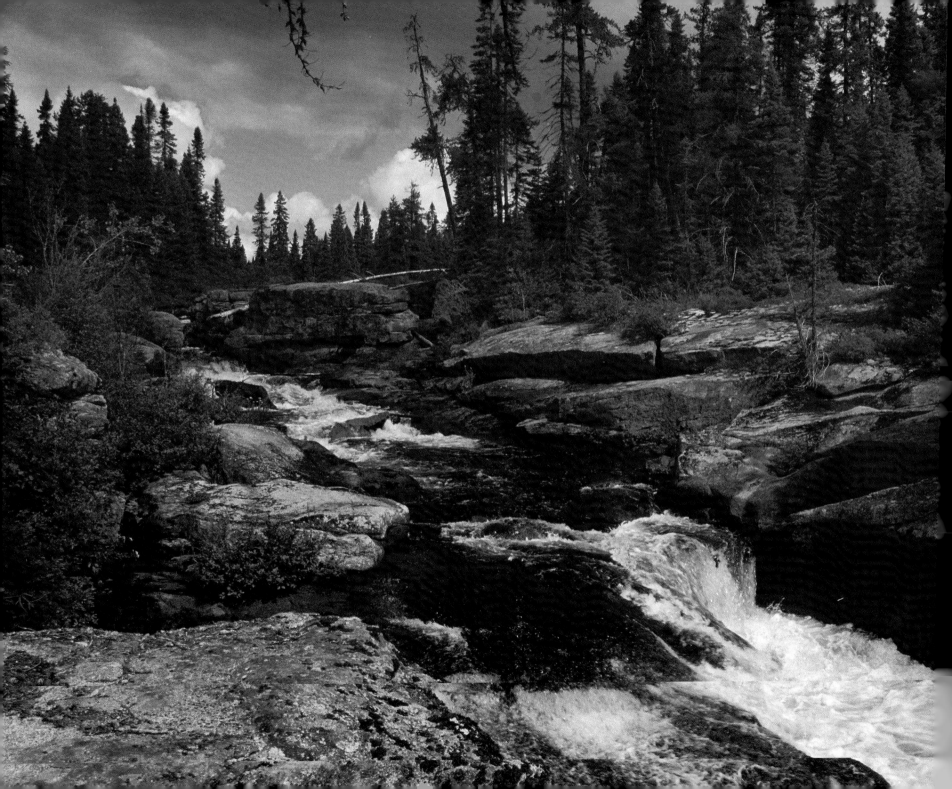

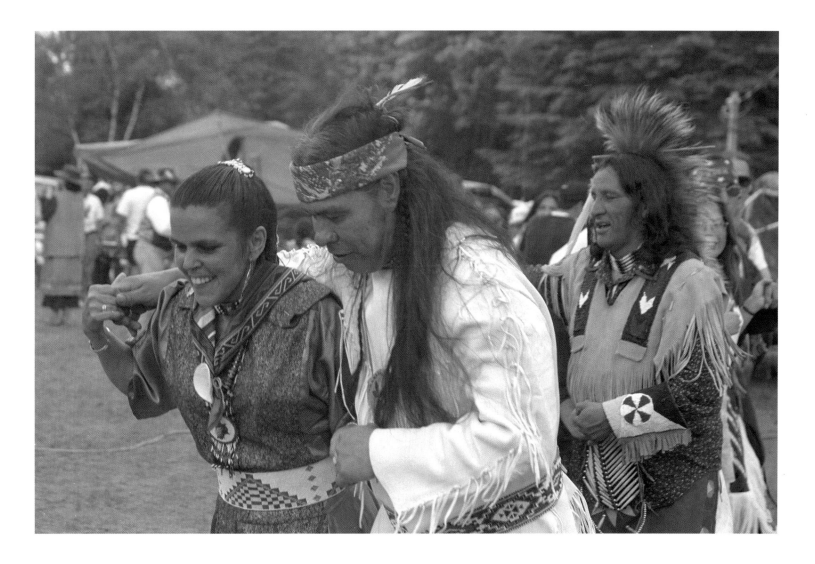

Metepenagiag celebration: Donna Augustine and George Paul lead a group of traditional dancers at the Red Bank First Nation Powwow (above); at the Palisades, bold, white water gushes over jagged rocks and falls tumbling to the Little Southwest Miramichi (opposite).

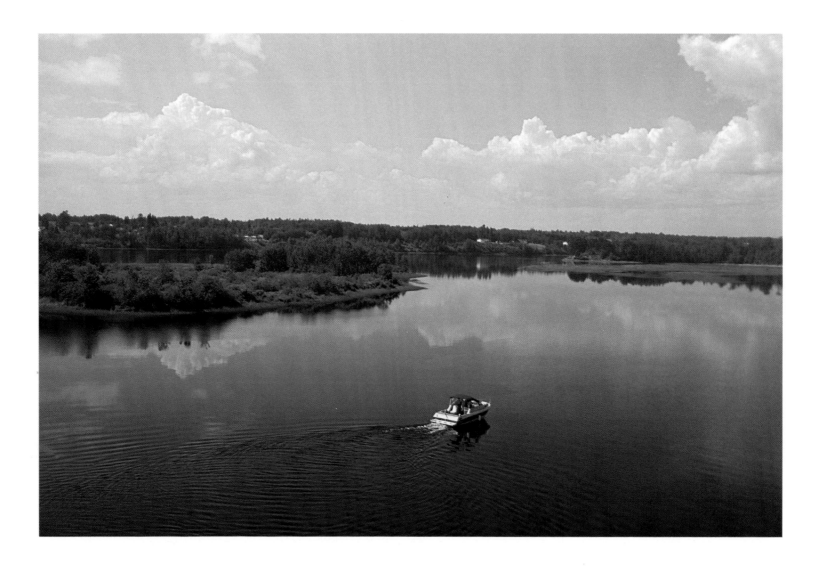

Southwest Miramichi River near Barnaby.

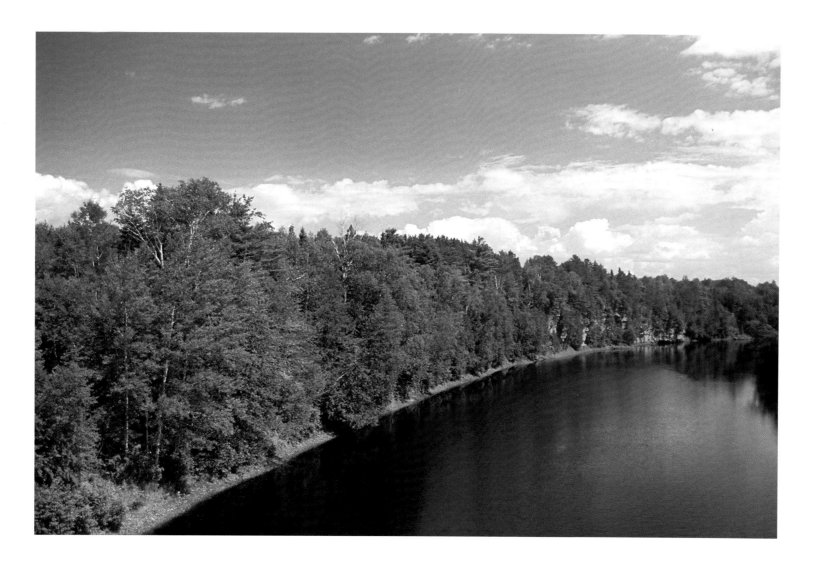

Barnaby River bend.

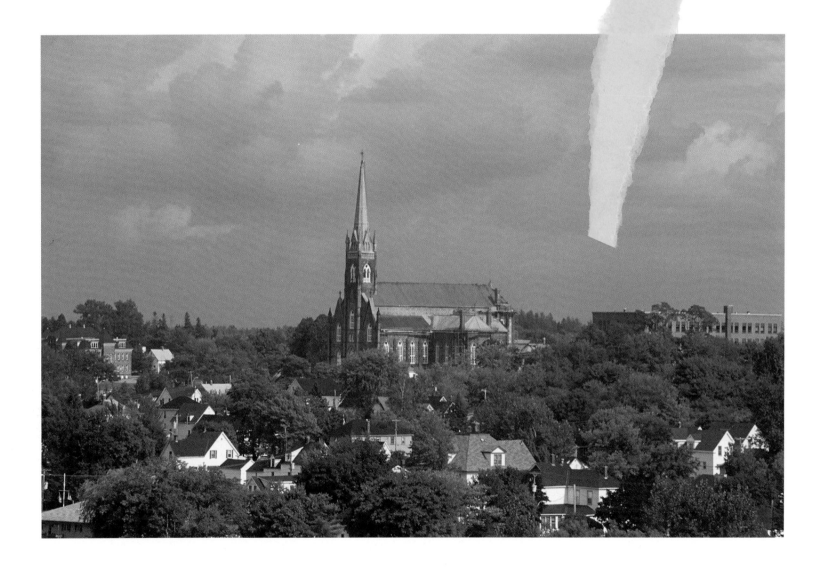

Church on the hill: Historic St. Michael's Basilica overlooks the former town of Chatham in Miramichi East.

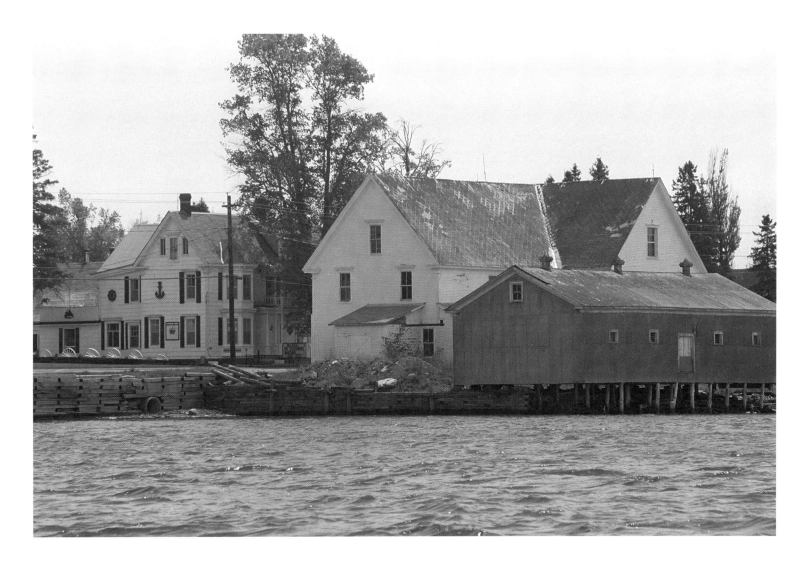

Governor's Mansion Estate at Nelson-Miramichi.

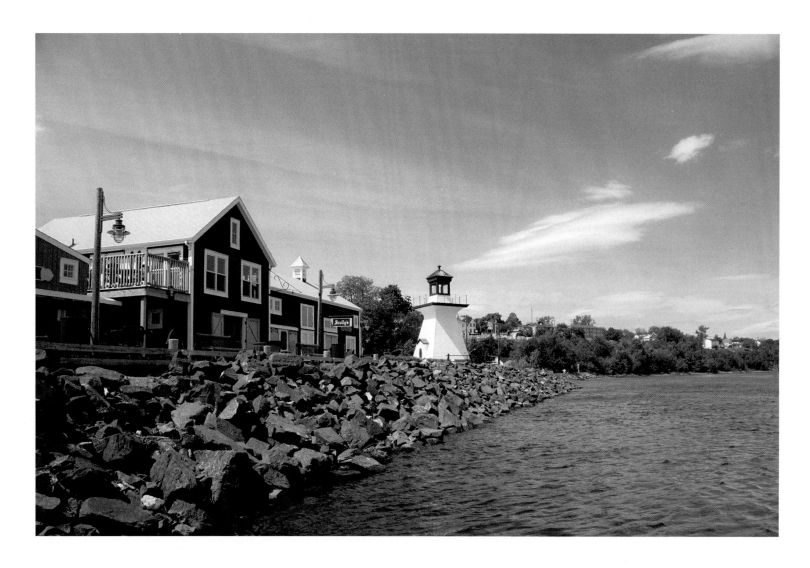

Ritchie Wharf on the Miramichi West waterfront (in the former town of Newcastle) is a favourite location for tourists and locals alike.

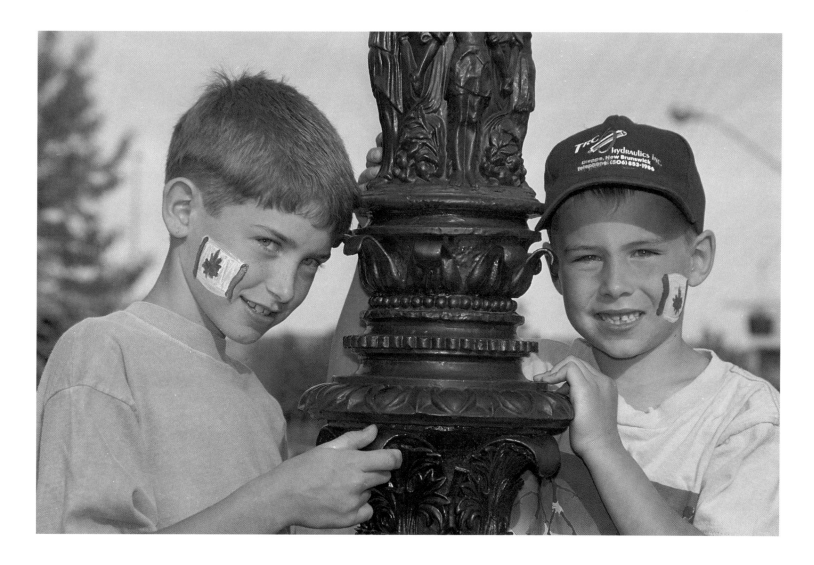

*Canada Day children: Cory Matchett and Freddie Haining of South Esk enjoying Canada Day celebrations
in the Newcastle Town Square.*

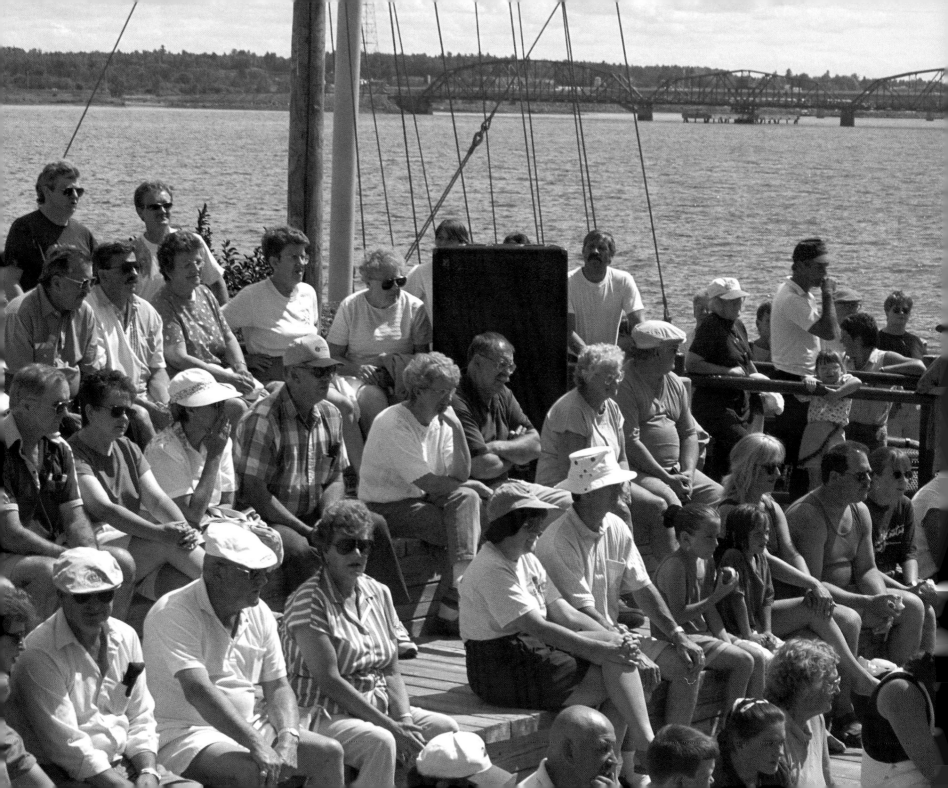

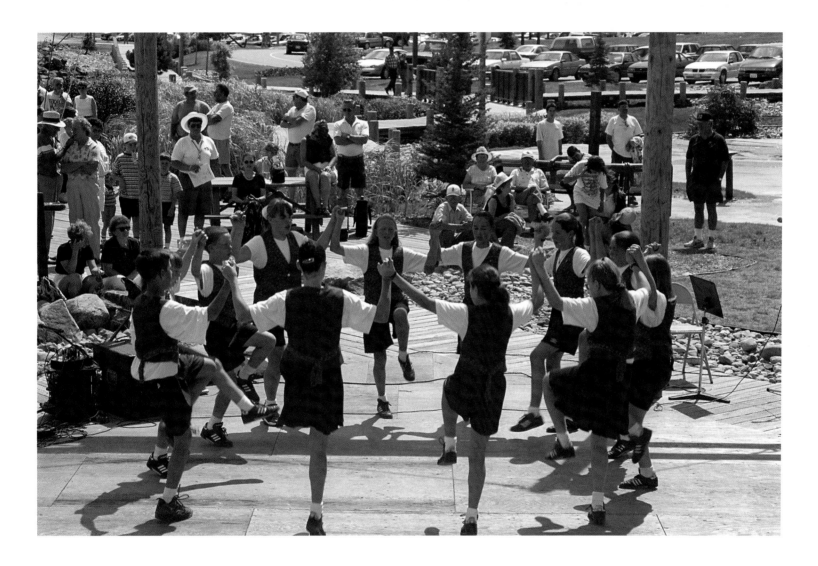

Doyle Dancers entertaining at Ritchie Wharf (above); an attentive audience looks on (opposite).

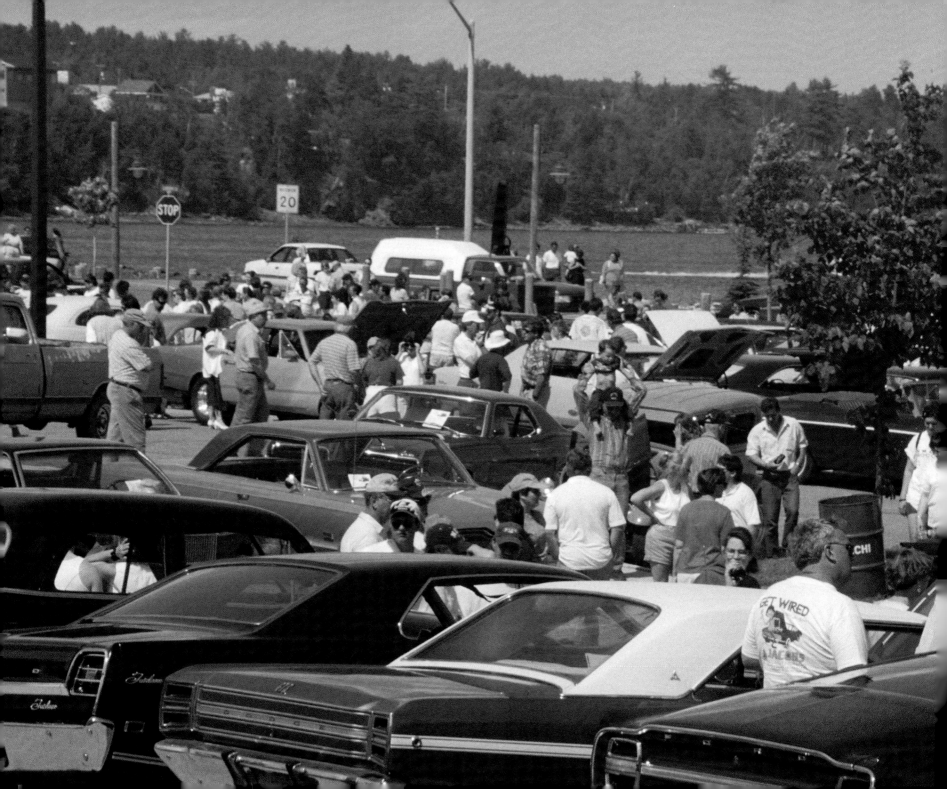

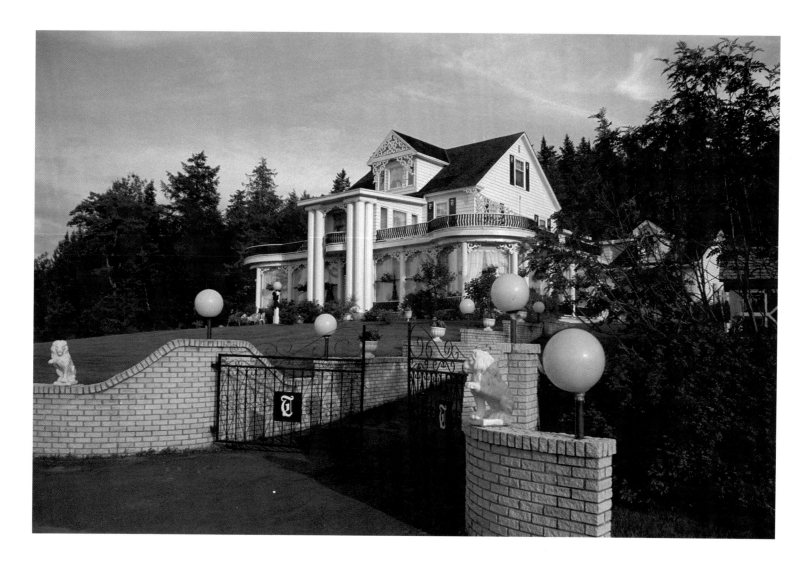

Taylor Home in Doaktown (above); the Goodie Shop Restaurant's Golden Oldie Car Show is held in conjunction with the Newcastle Business Association's Rock'n Roll Weekend in early July (opposite).

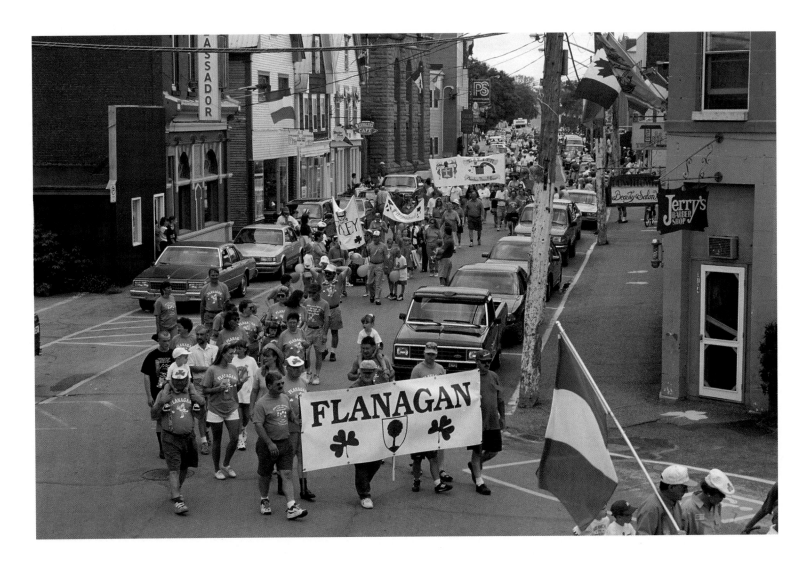

Proud to be Irish! A family parade is one of many highlights at Canada's Irish Festival on the Miramichi.
The event, traditionally held the third weekend in July, has been chosen as one of the top 100 events in
North America (above); members of the Miramichi Celtic Pipes and Drums are among many bands
and performers to bring music to the Irish Festival (opposite).

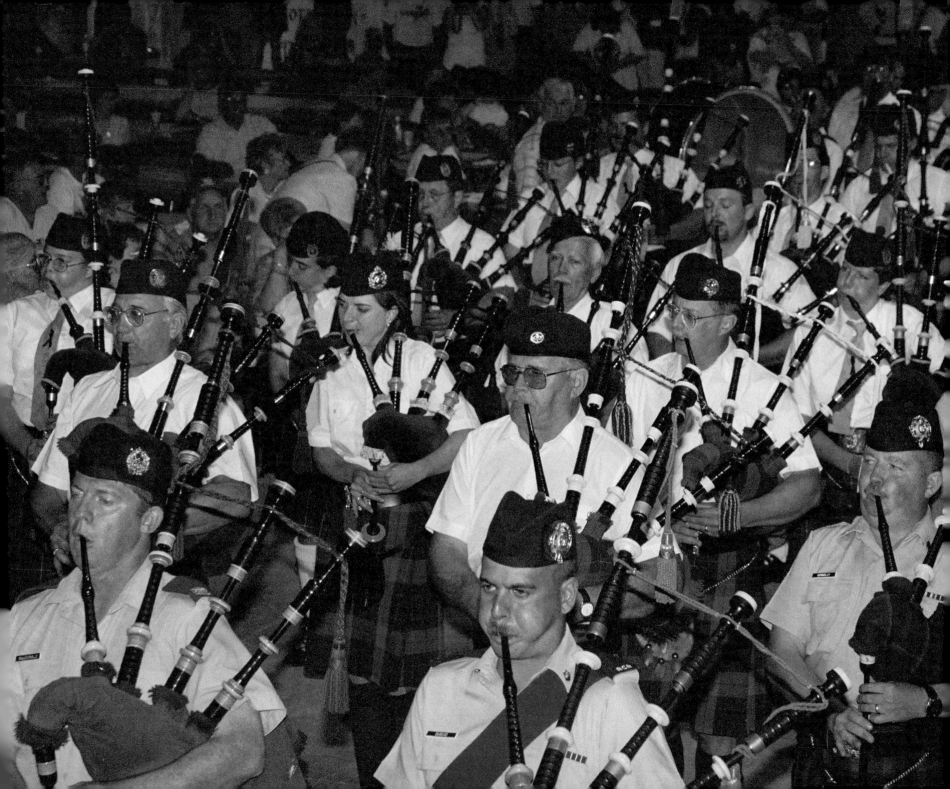

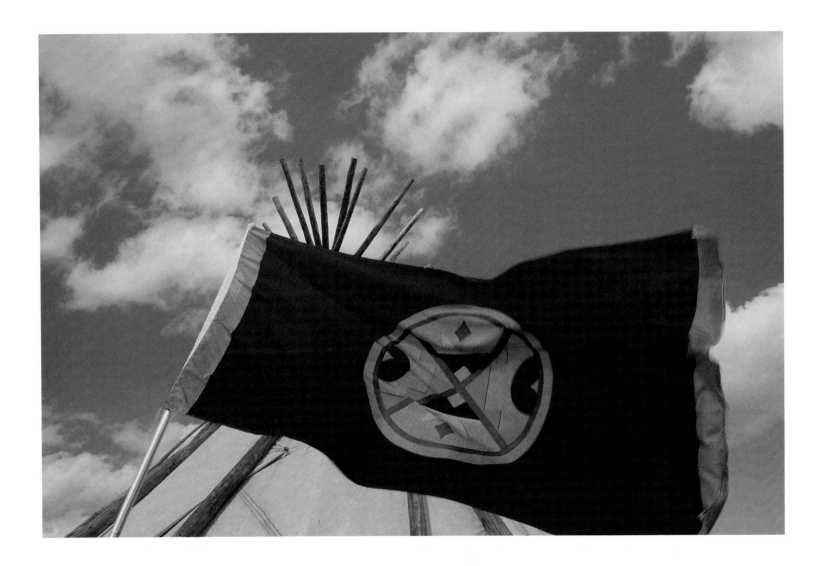

The colourful flag of Eel Ground First Nation welcomes everyone to the community for the traditional powwow and Feast of St. Anne celebrations

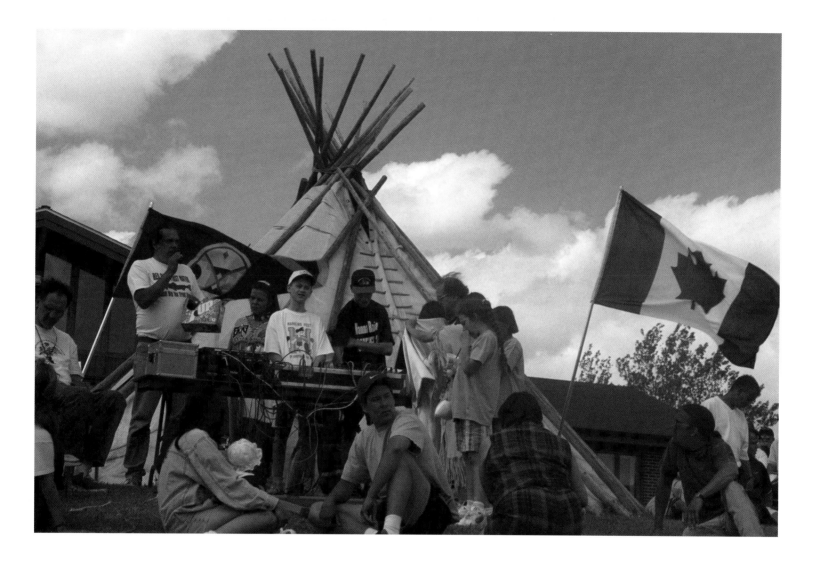

Participants at the powwow.

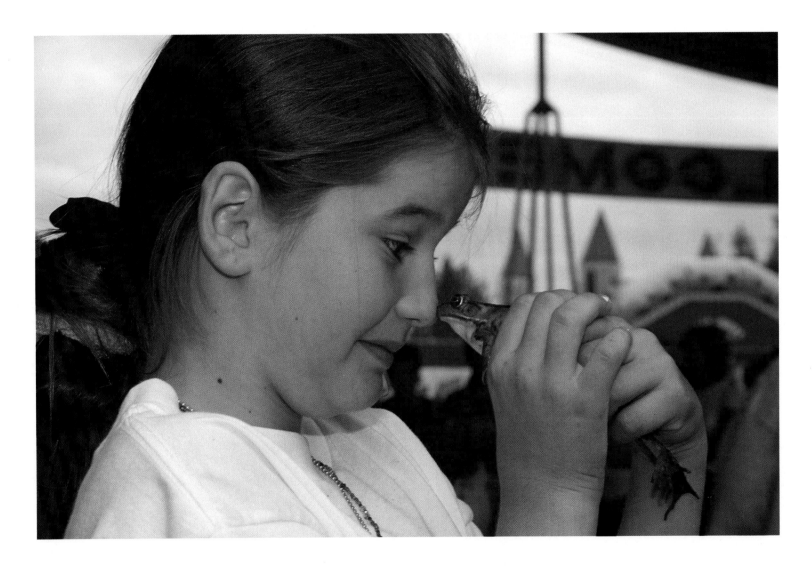

*The Bay du Vin Summer Survival features many events, including the popular frog race. Shown here is
Samantha Savage and her entrant (above); family fun at Middle Island (opposite).*

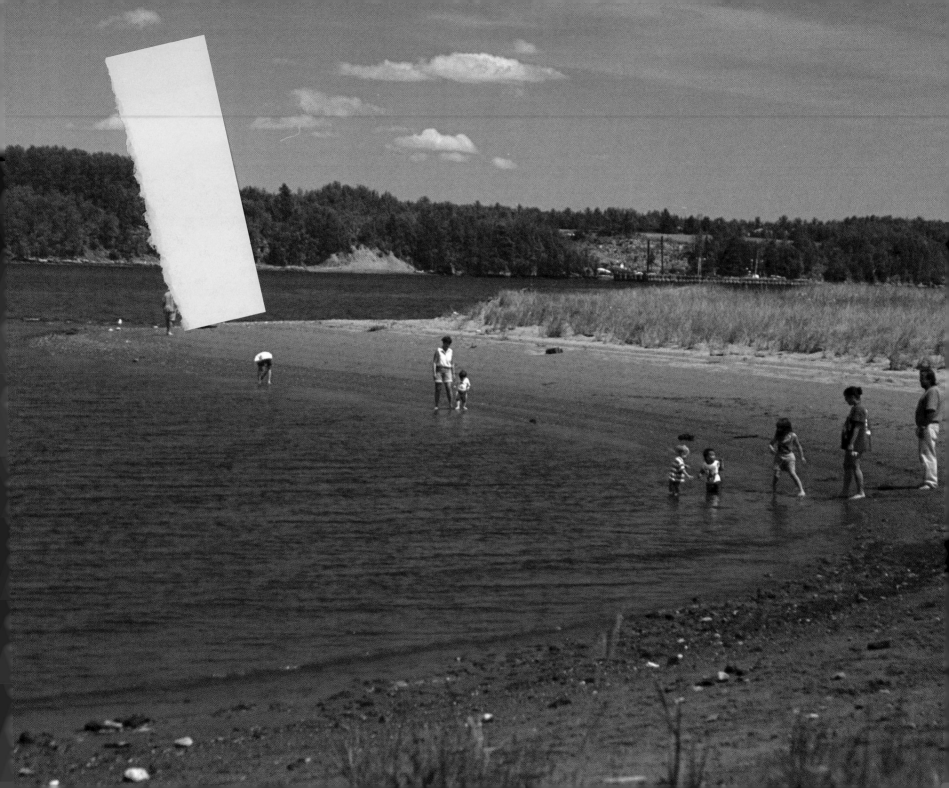

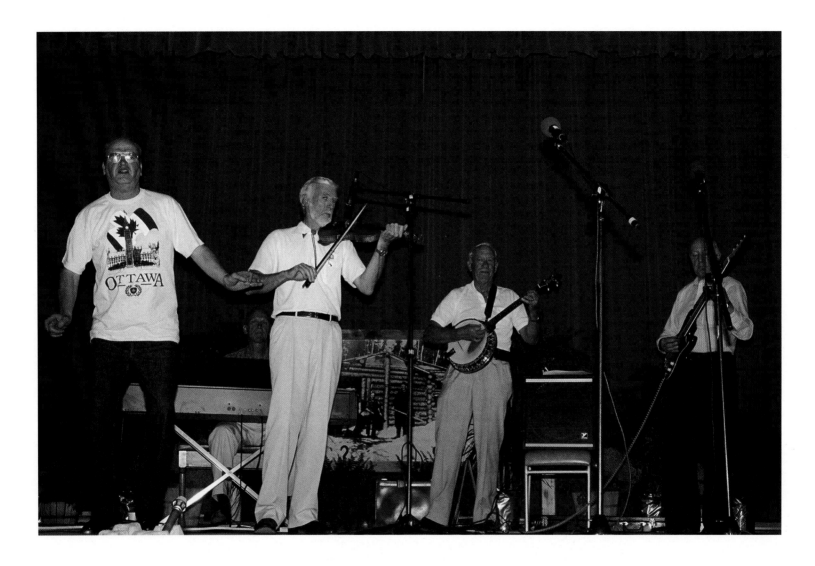

The annual Miramichi Folksong Festival, traditionally held the first week in August, features acclaimed provincial and international singers, as well as local performers such as step dancer Francis Taylor and the Down East Entertainers.

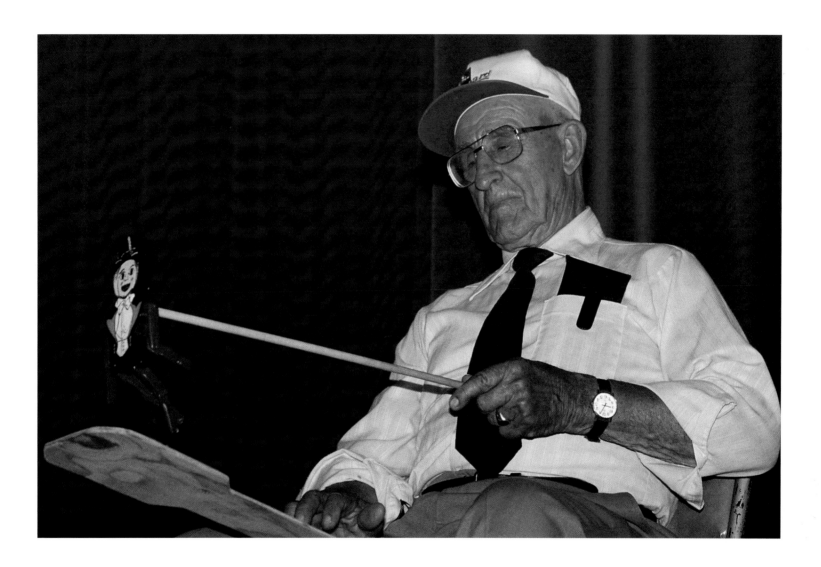

Johnny Gilks of South Esk performs at the festival with his wooden dancing man.

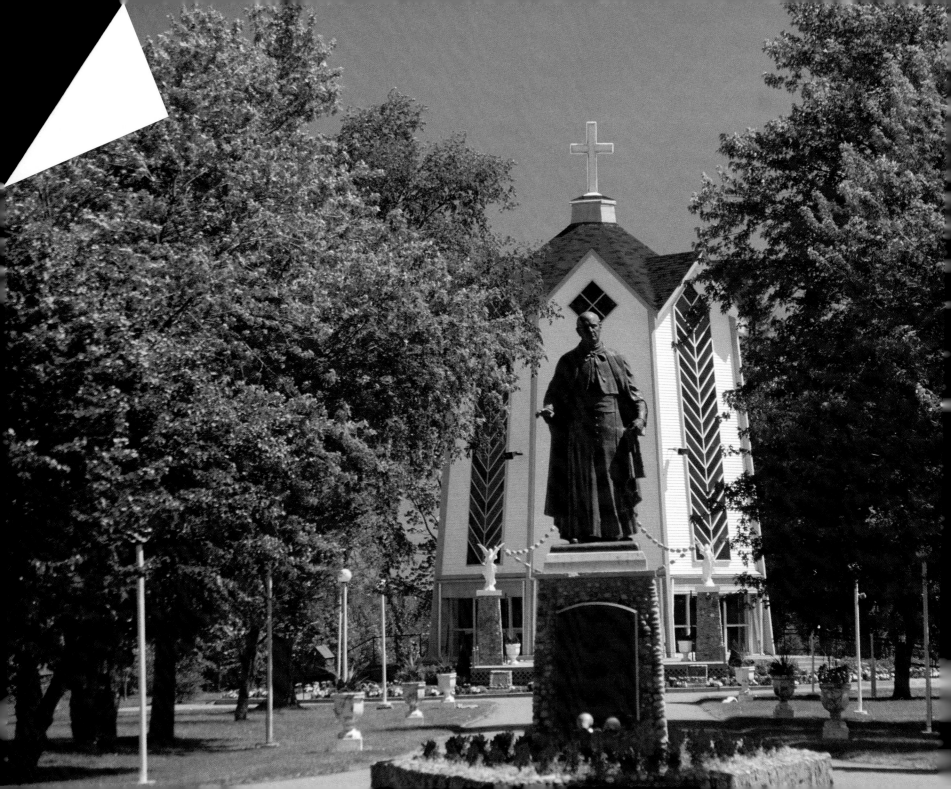

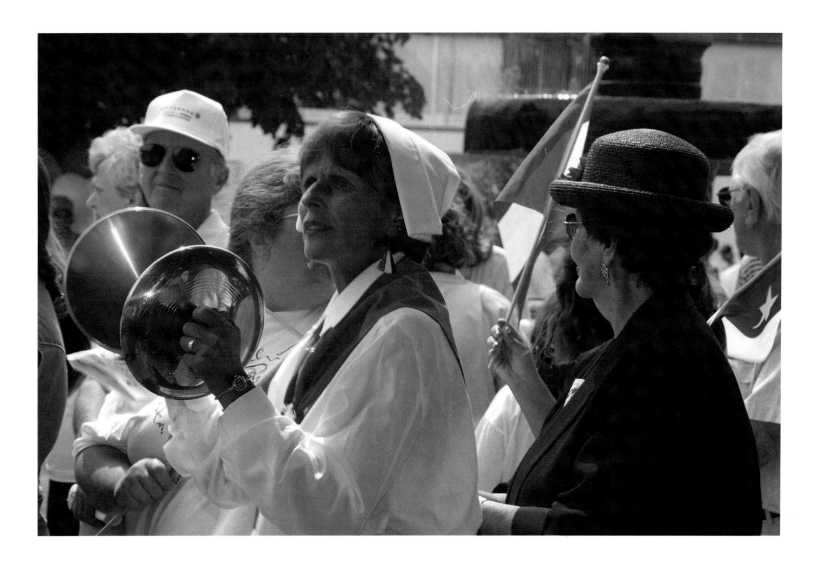

*Monette Turbide of Baie Ste. Anne celebrates her heritage at Acadian Day festivities on August 15 in the
Newcastle Town Square (above); Acadian National Monument at Rogersville (opposite).*

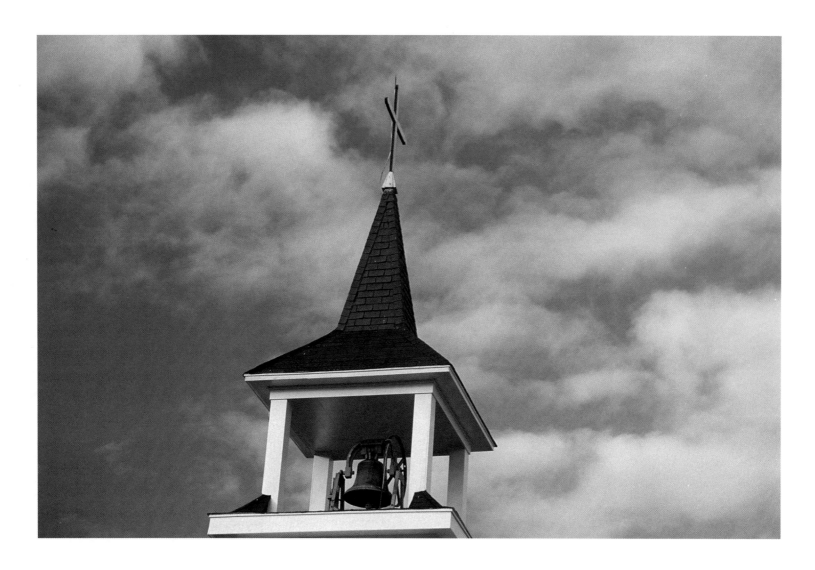

Holy Family Catholic Church in Barryville (above); the Priceville Footbridge at Carroll's Crossing (opposite).

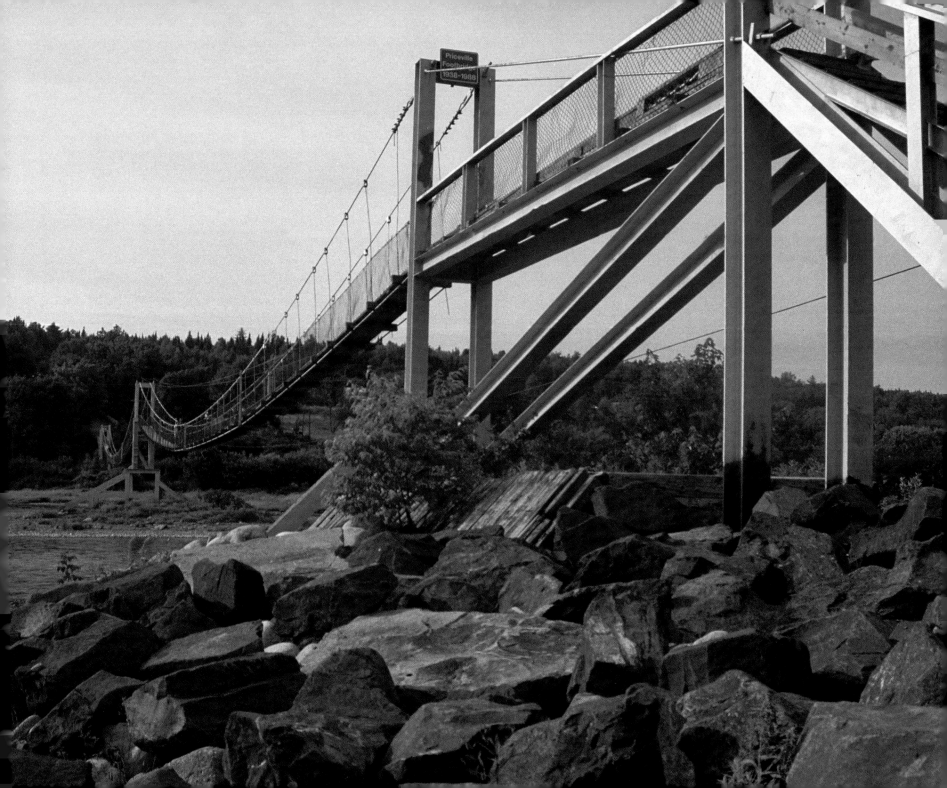

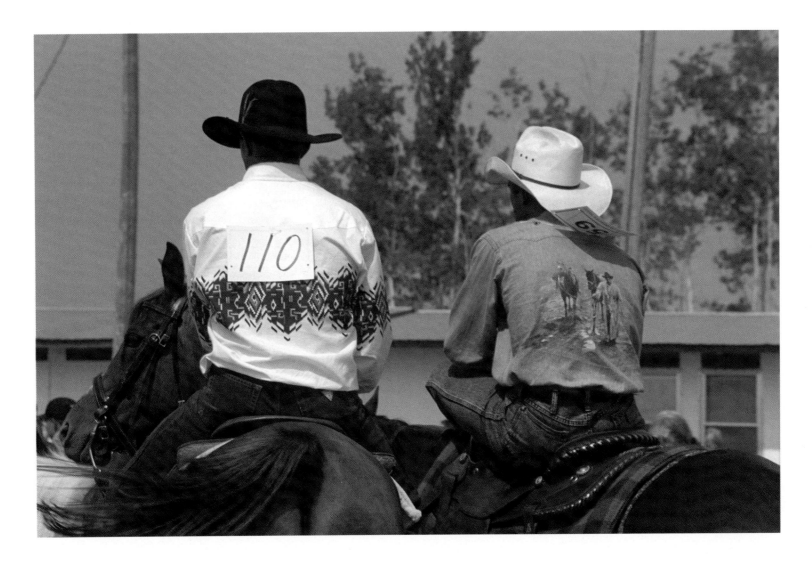

The Napan Agricultural Show features livestock, produce, local entertainment, games, and family fun. Here, two cowboys wait their turn in the show ring at the annual horse show.

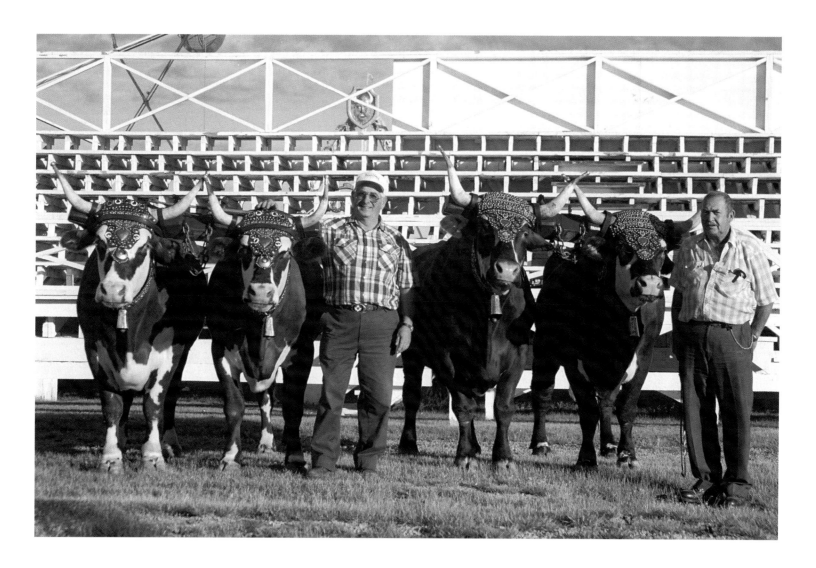

Gerald Langille of Mahone Bay, Nova Scotia, and Raymond Hanley of Liverpool, Nova Scotia, with their oxen at the Miramichi Agricultural Exhibition.

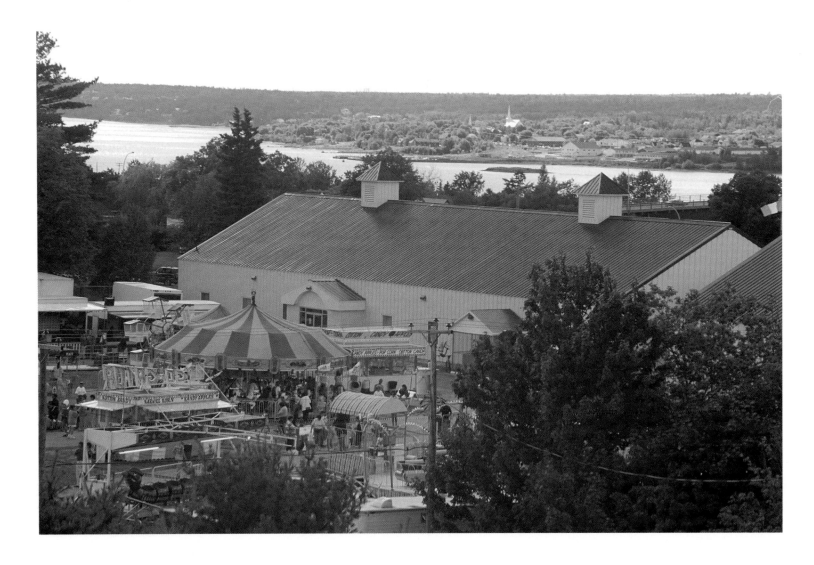

The Miramichi Agricultural Exhibition in Miramichi East (Chatham) is a landmark event every August.

Ashley MacDonald of Black River Bridge and Danny Huskins of Cape Island, Nova Scotia, at the Miramichi Agricultural Exhibition.

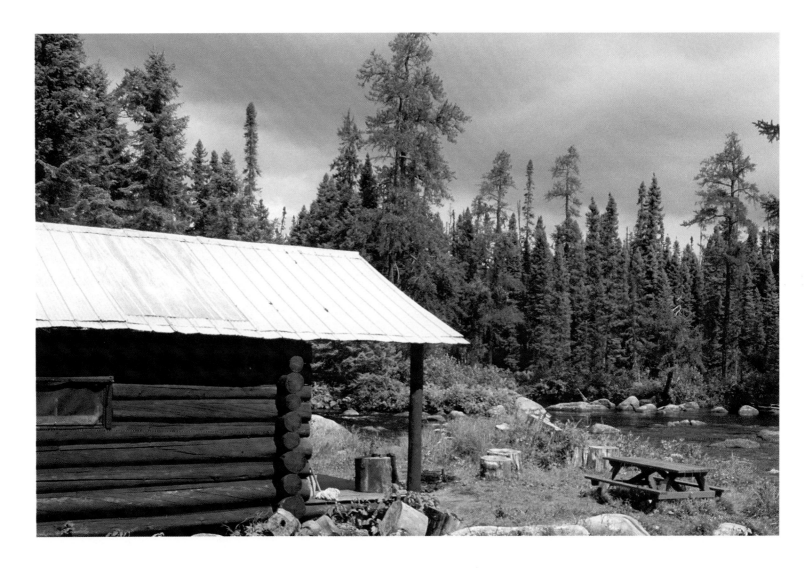

Ramsay Lodge at North Pole (above); Red Bank (opposite).

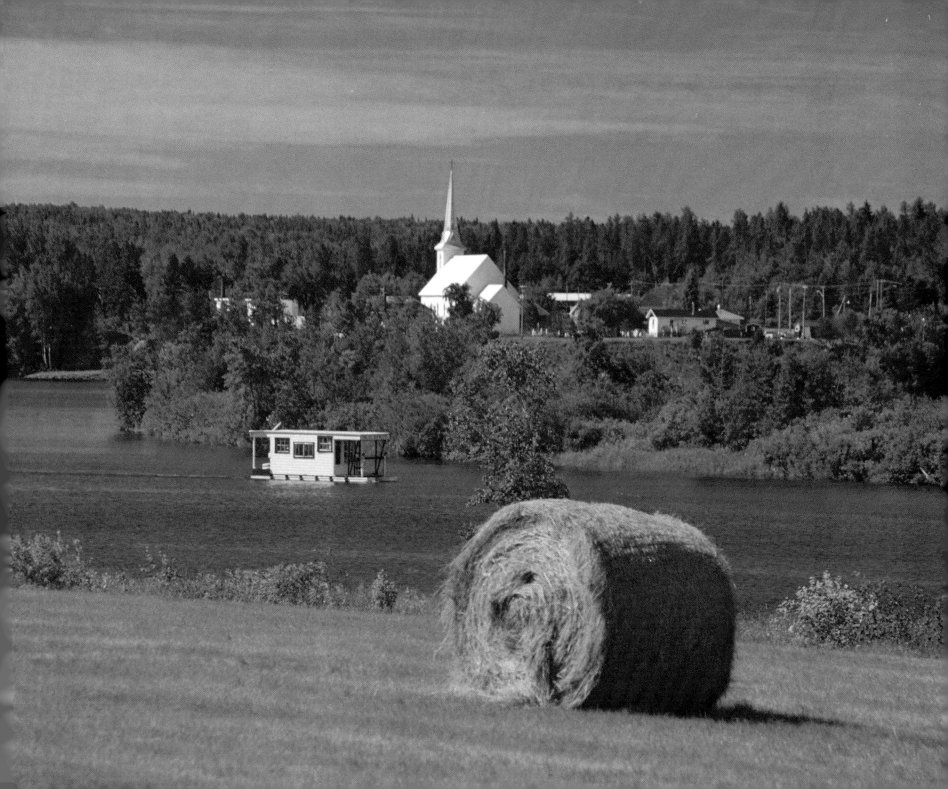

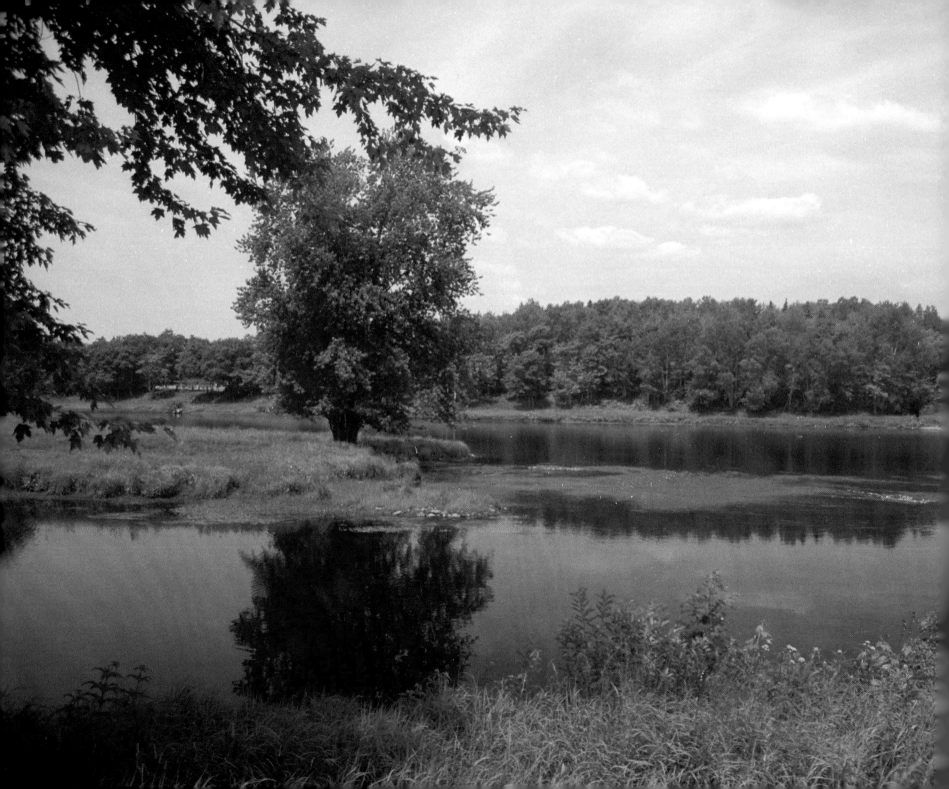

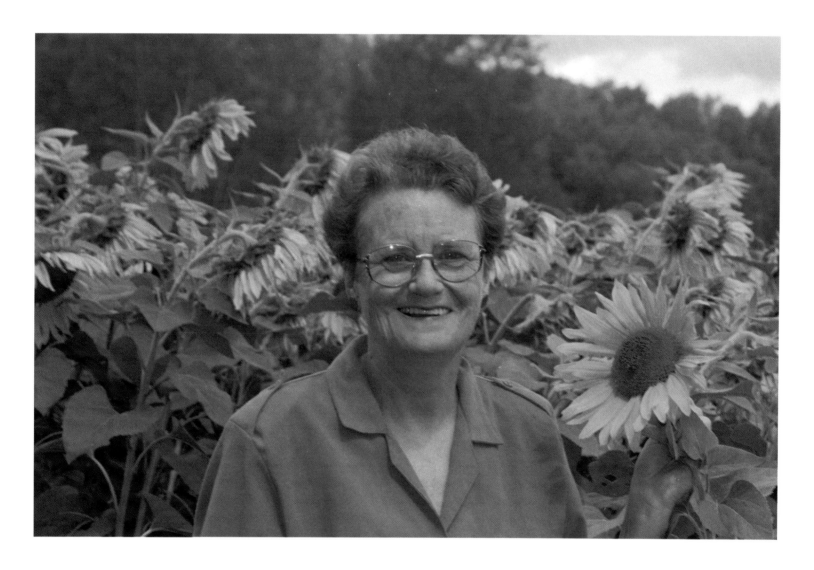

*Helen Sturgeon of Upper Derby with sunflowers in Doaktown (above); Southwest Miramichi at the
Atlantic Salmon Museum in Doaktown (opposite).*

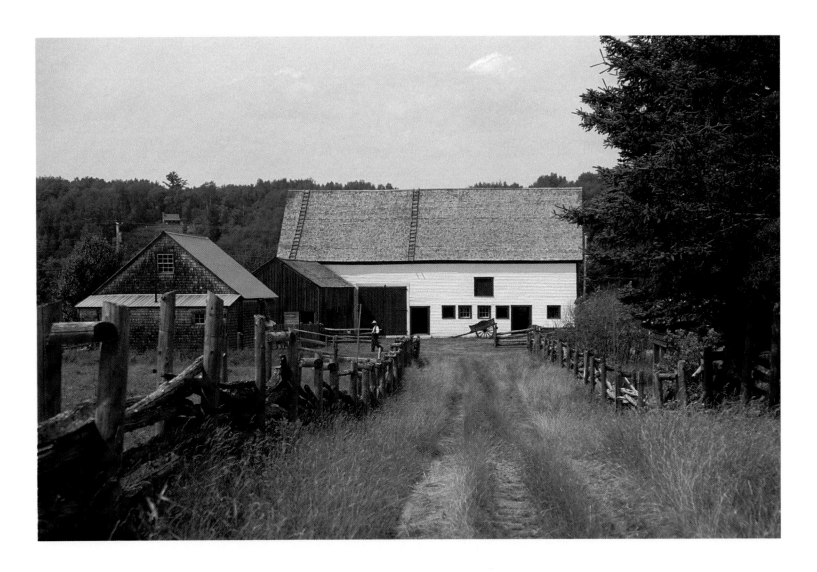

*The Doak Historic Site on Doaktown's main street is a living museum commemorating
life in the community in the 1800s.*

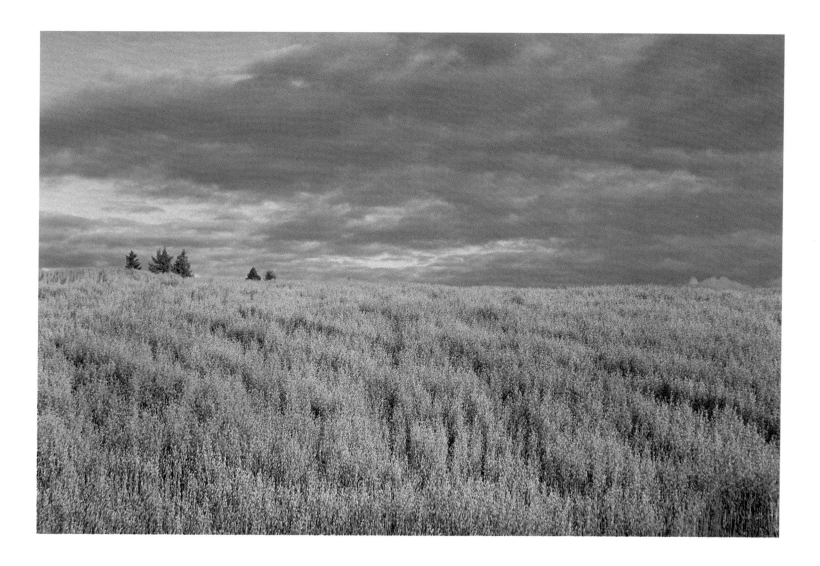

Summer oat field in Nelson-Miramichi.

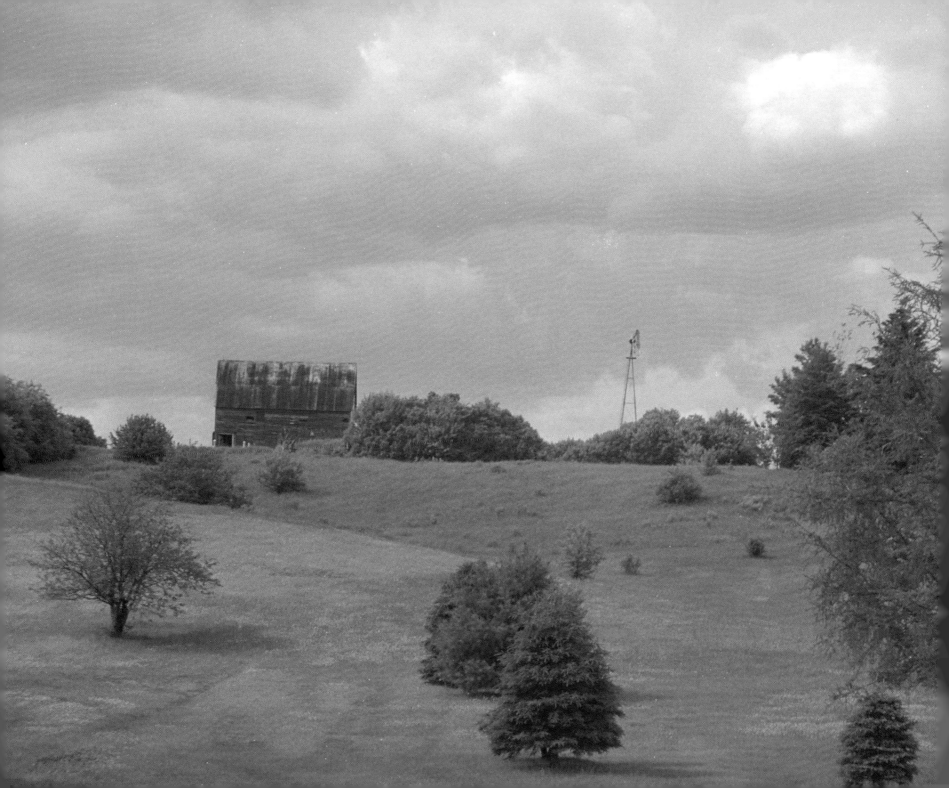

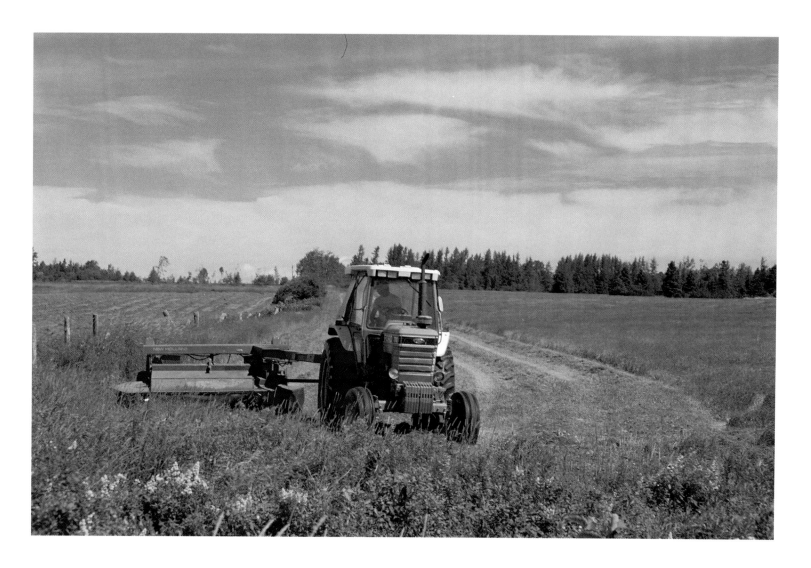

Summer harvest at Schenkels' Farm in Whitney (above); Whitney (opposite).

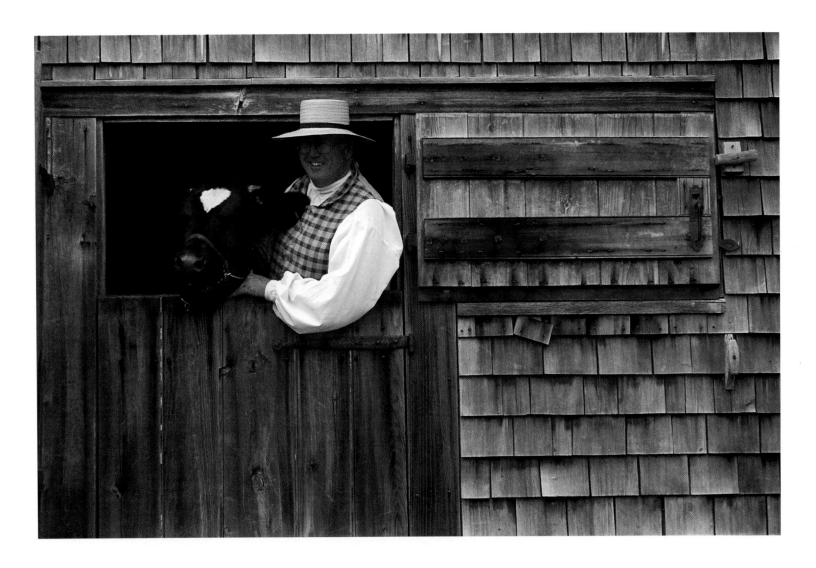

MacDonald Farm Historic Site in Bartibog was home to Scotsman Alexander MacDonald and his family in 1820.
Costumed guides including supervisor Blair Carter greet visitors here.

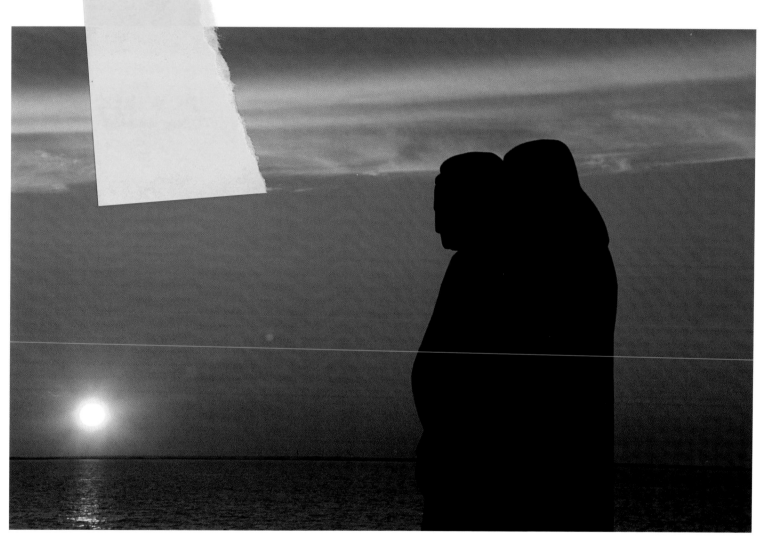

Claude Roussel's dramatic sculpture at Escuminac wharf serves as a constant reminder of New Brunswick's worst marine disaster. Thirty-five men and boys left the wharf to go fishing on June 19, 1959, and never returned.

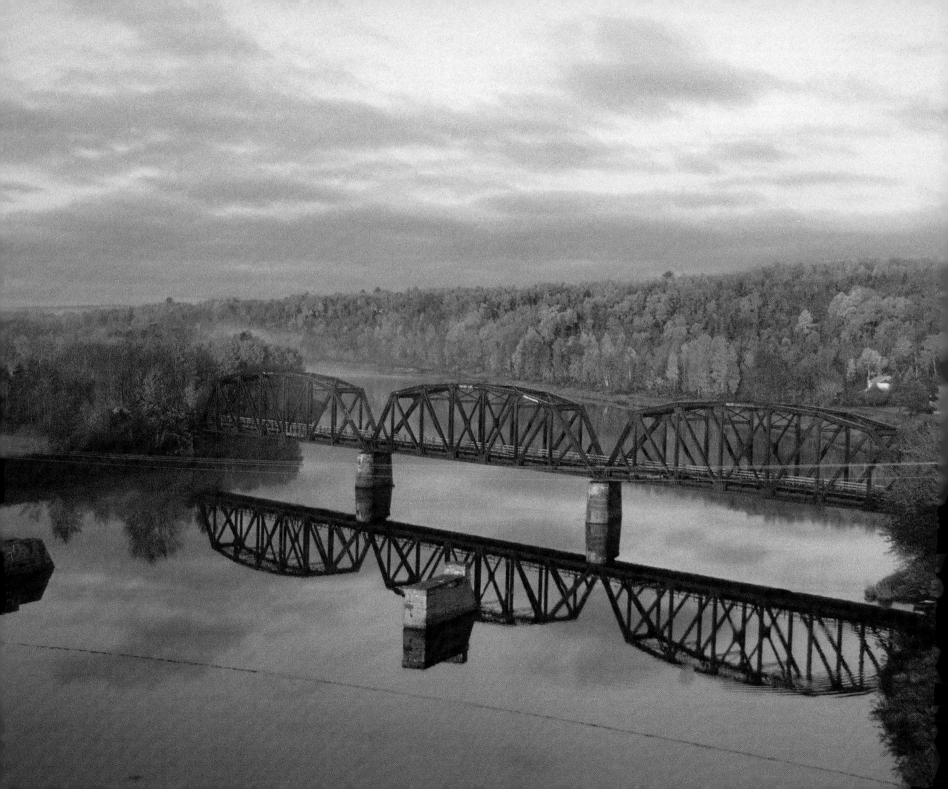

Autumn

Jack Frost arrives in the dead of night leaving a magical trace behind. Leaves transpose into spectacular shades of reds and yellows. Watch as they waltz in the wind bidding a final farewell to the season. Autumn always wears a new exciting face. It's always changing, but consistently beautiful. Fishers continue to dot the Miramichi River hanging onto their rods of hope in cool, rippled waters. Take a drive in Miramichi and discover perfection in this picturesque land wherever you go.

Harvest memories, relax and reminisce.

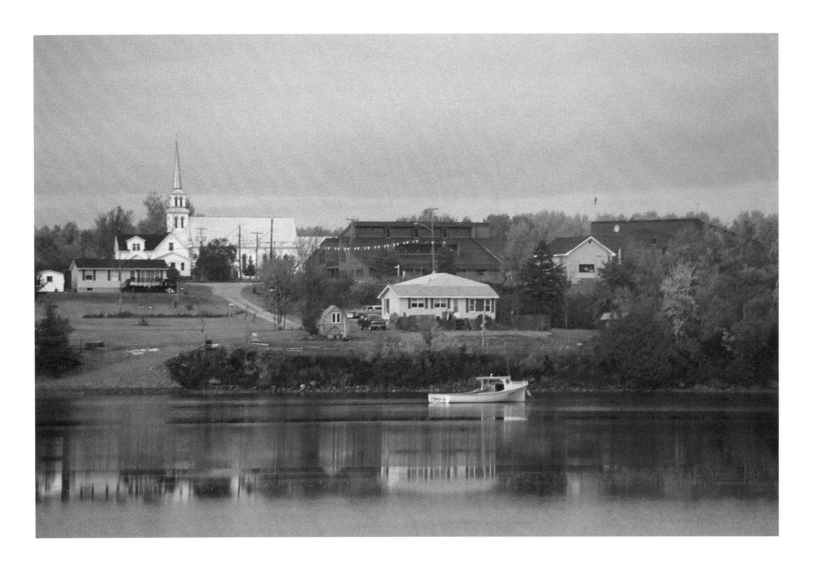

Eel Ground First Nation.

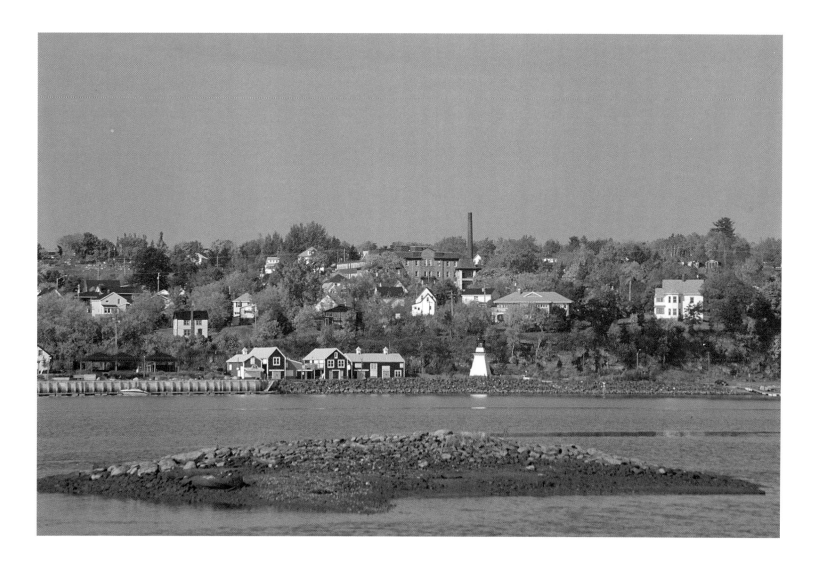

Miramichi West waterfront.

Leonard MacKnight of Napan heading to his woodlot (above); Dr. Hans Weber brought a little bit of Bavaria to the Miramichi when he built for his wife, Marianne, this chapel on their estate at Black River Bridge (opposite).

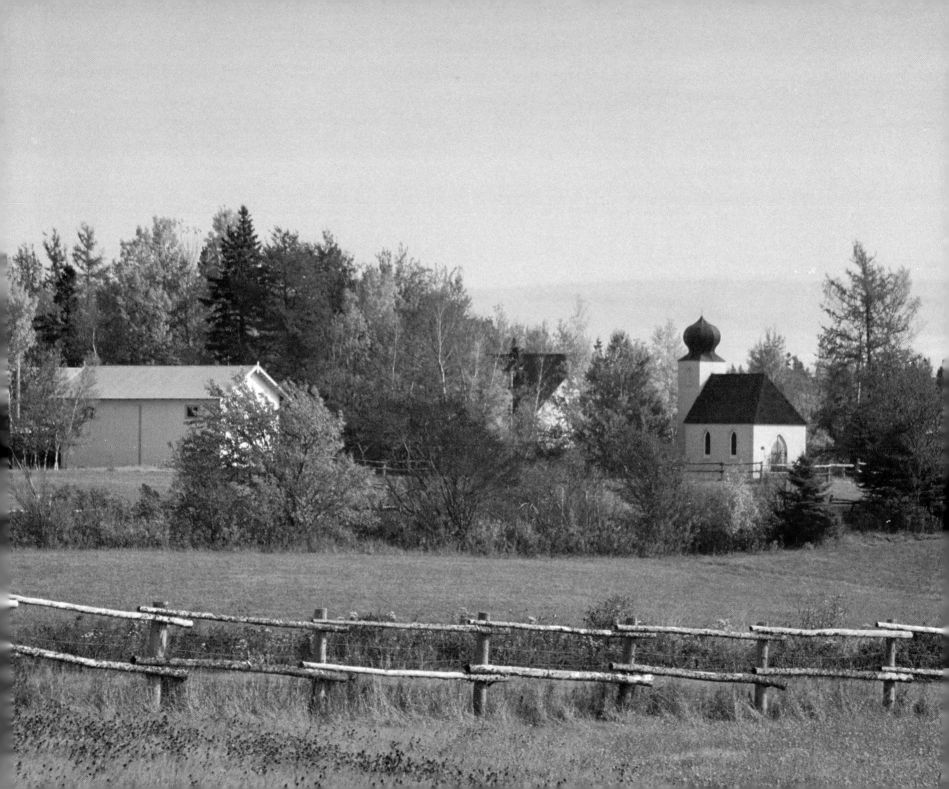

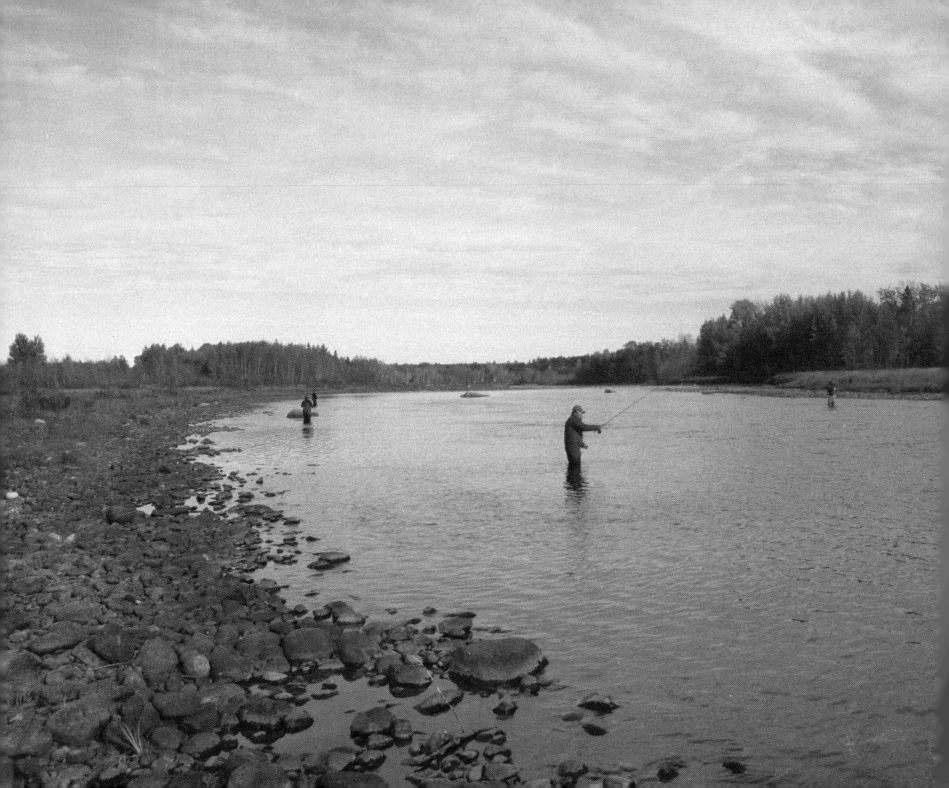

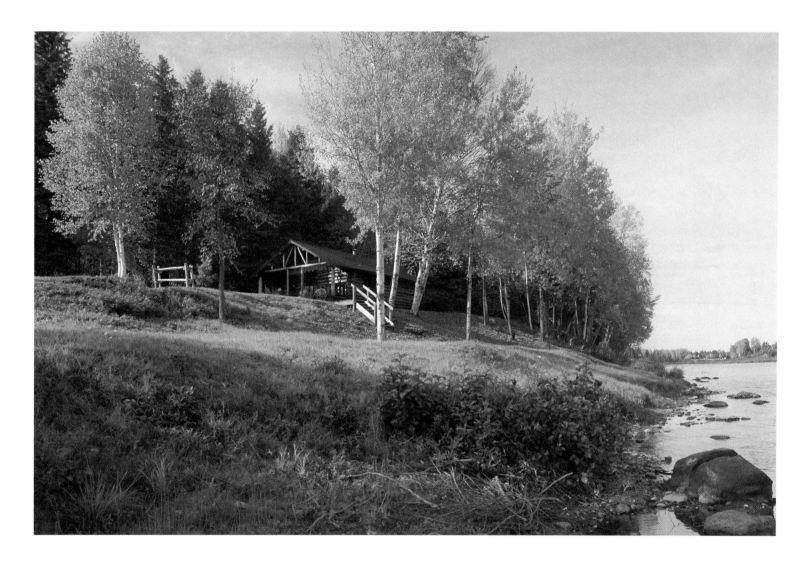

Derrick and Laura Hare's camp on the Northwest Miramichi River (above);
some fall fishers try their luck (opposite).

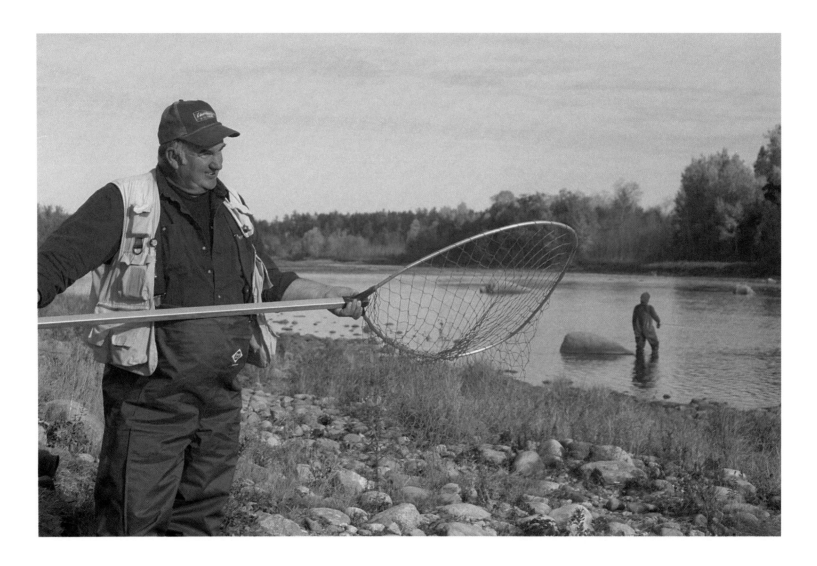

Veteran guide Frank Somers on the Little Southwest Miramichi River at Halcomb (above and opposite).

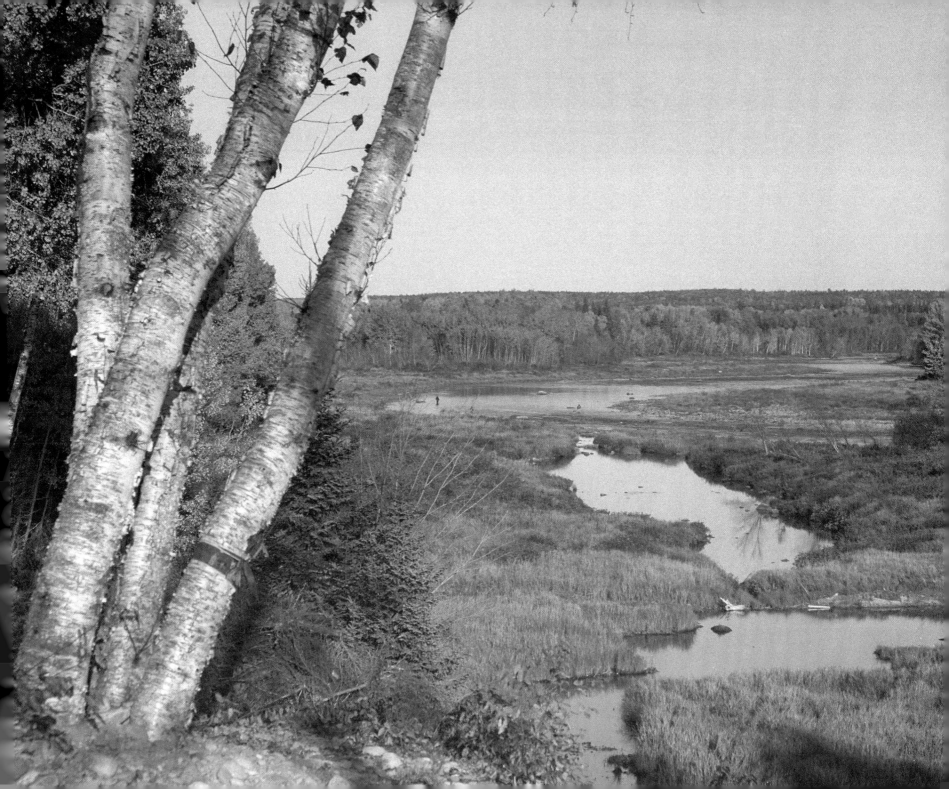

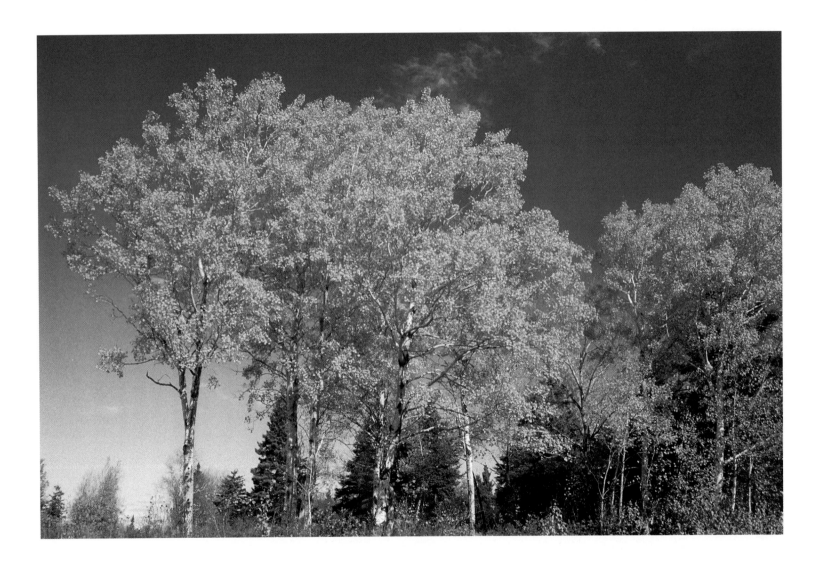

Colours of autumn in North Barnaby.

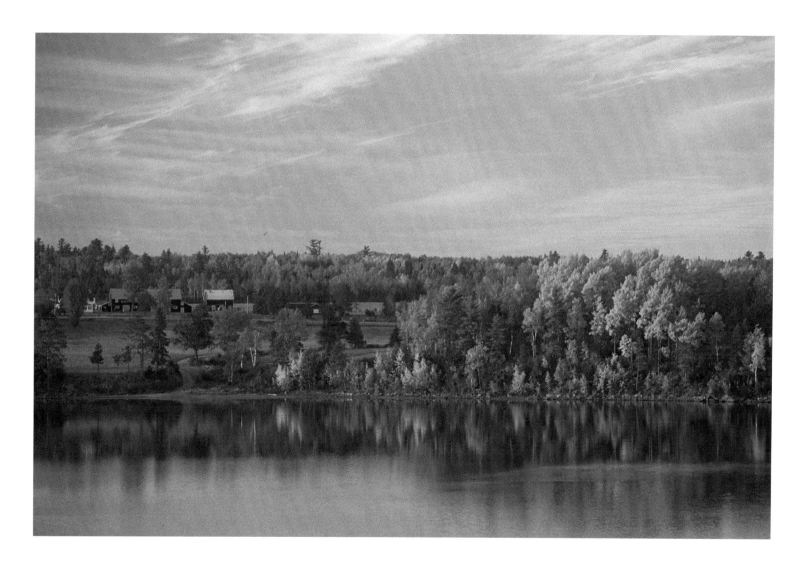

The Northwest Miramichi River at Cassilis and Frank and Joan Menzies' farm at Whitney.

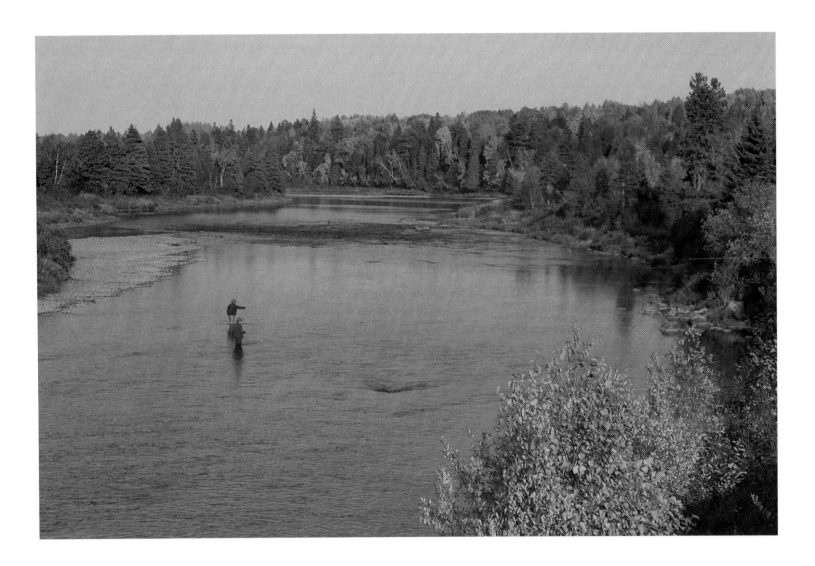

Fishing the Little Southwest Miramichi River at Sillikers.

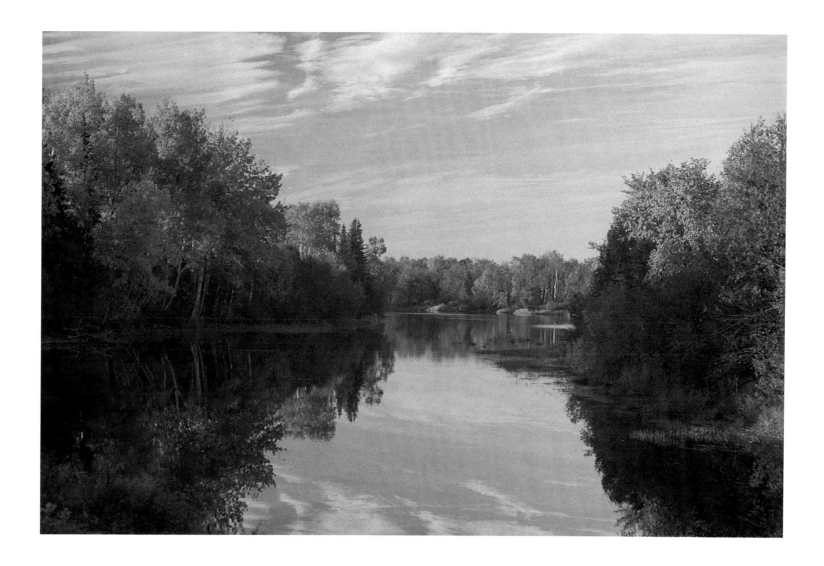

Red Bank.

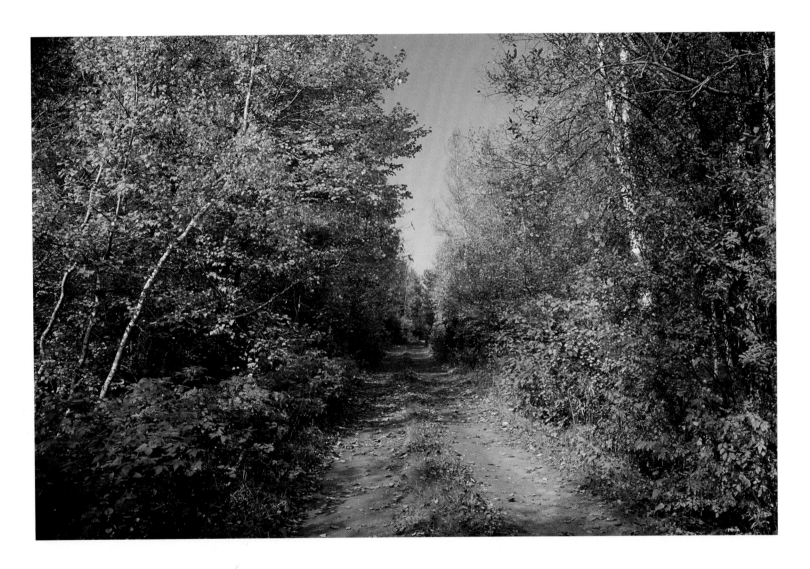

Autumn trail at Black River Bridge (above) and autumn colours in Halcomb (opposite).

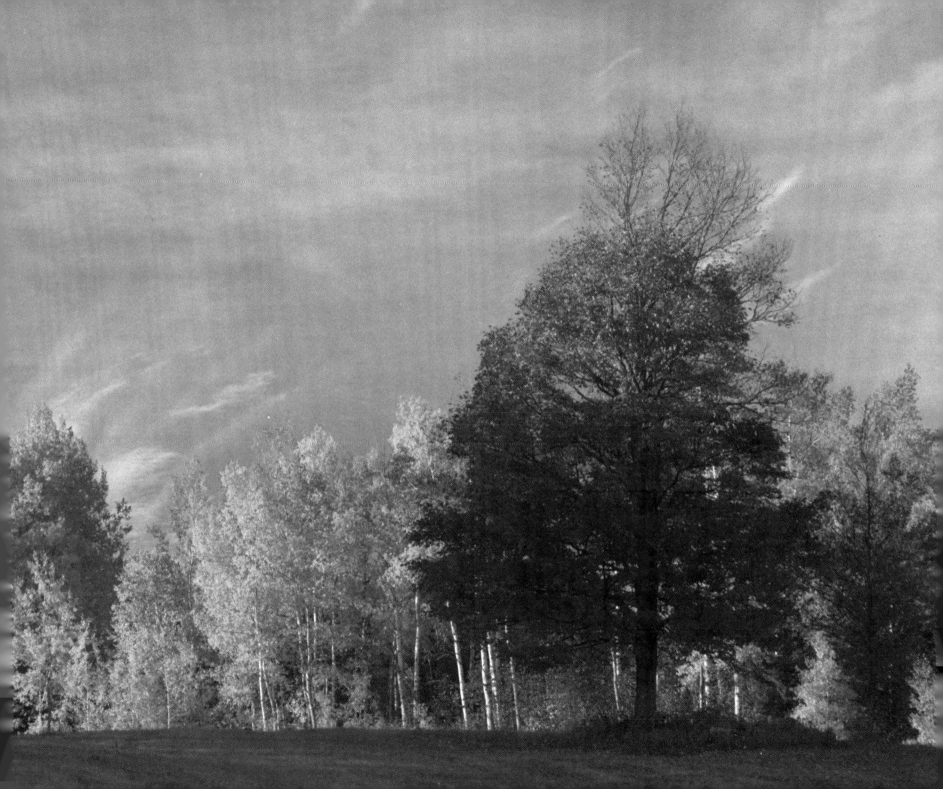

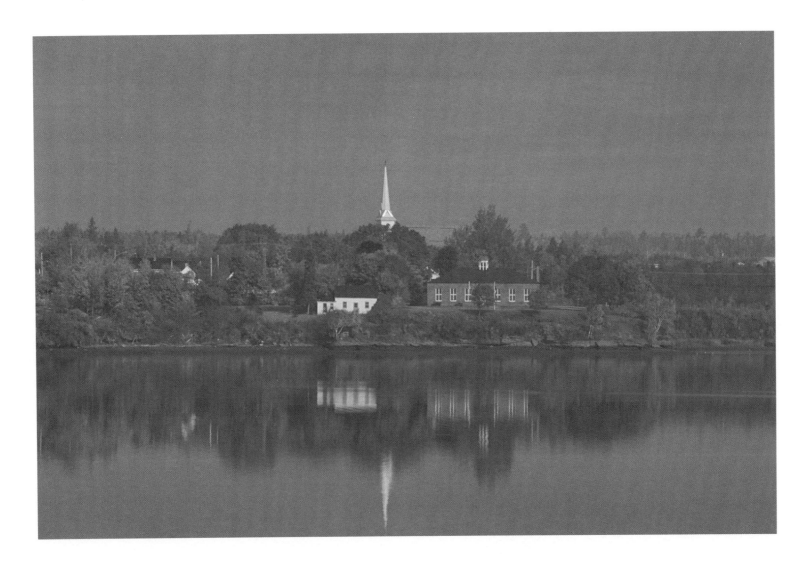

The Seaman's Hospital at Douglastown, right, built of Miramichi sandstone in 1830, is the oldest existing marine hospital in Canada. This National Historic Site is just across the street from St. Samuel's Church.

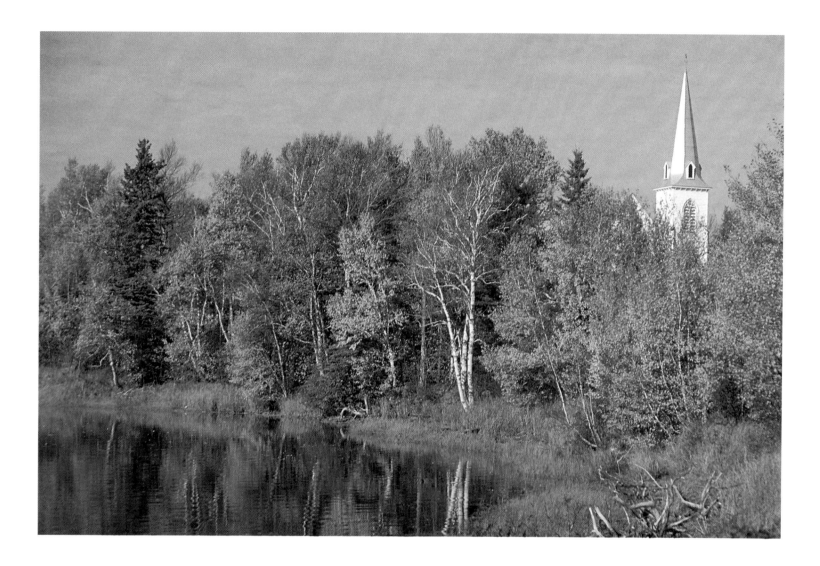

St. Stephen's United Church in Black River Bridge hosts a Fall Harvest Supper every Labour Day.

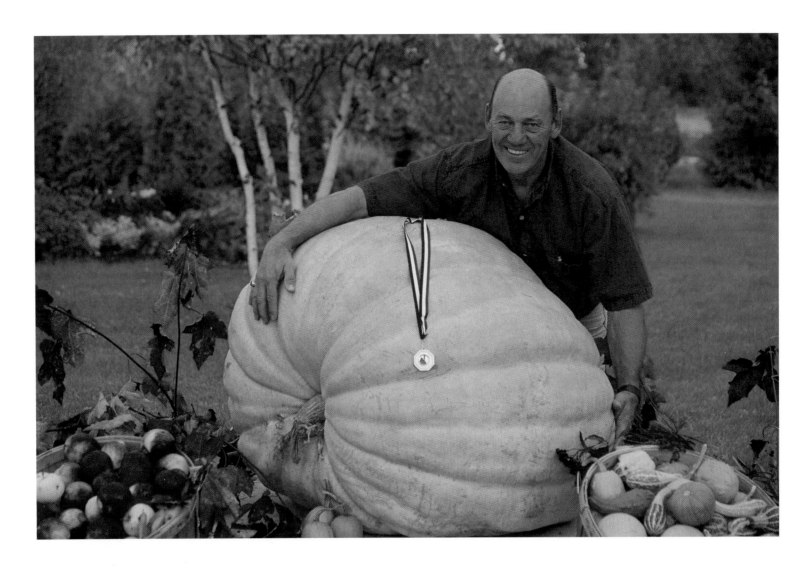

Camille Breau of Lower Neguac and a prize-winning pumpkin.

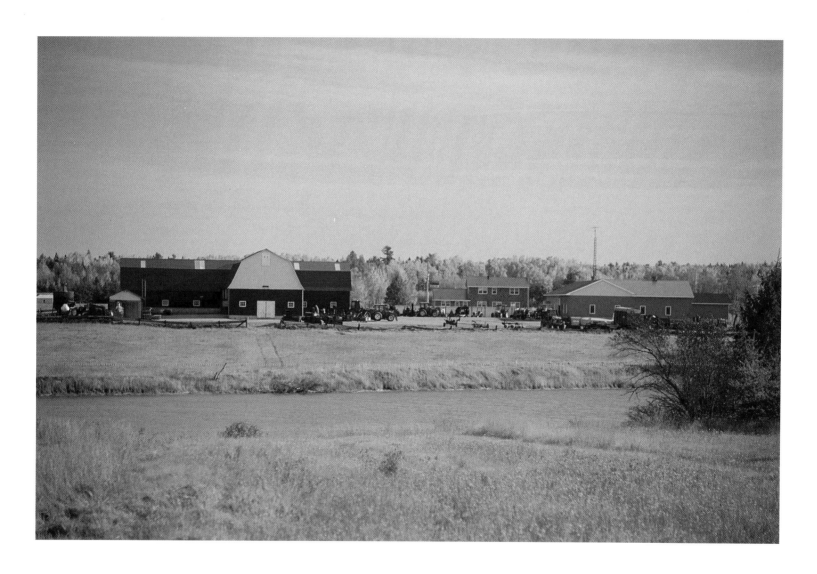

Bremner Farms Ltd. in Napan is home to 1997 Miramichi Achiever Leon Bremner.

Autumn art in Bay du Vin (above); Baie Sainte-Anne sand dunes (opposite).

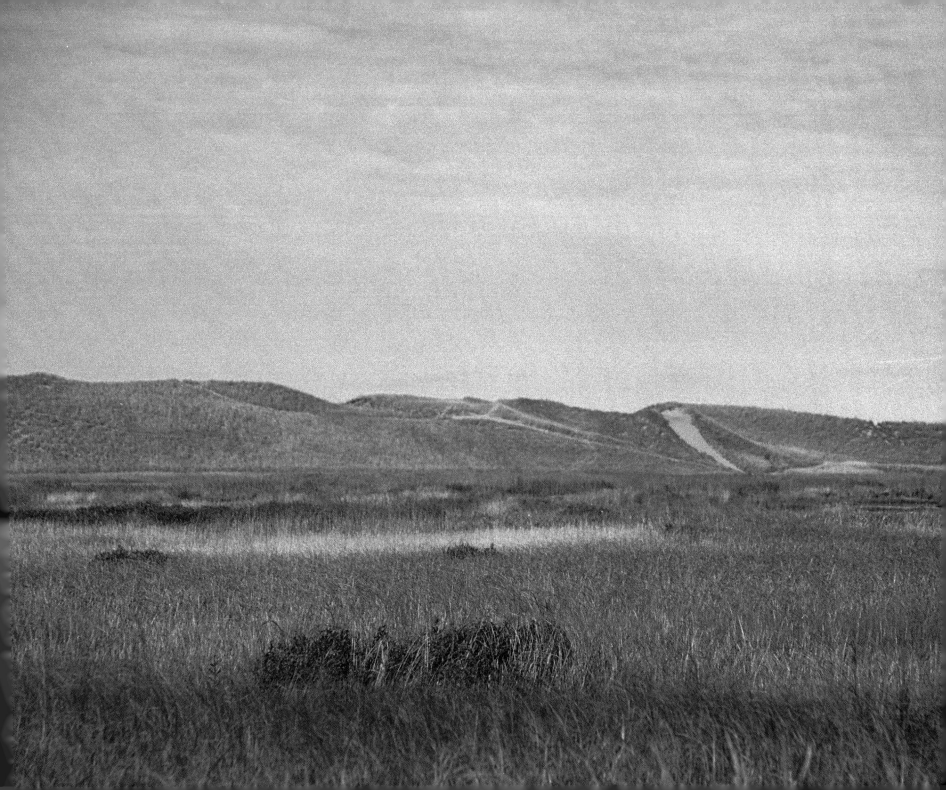

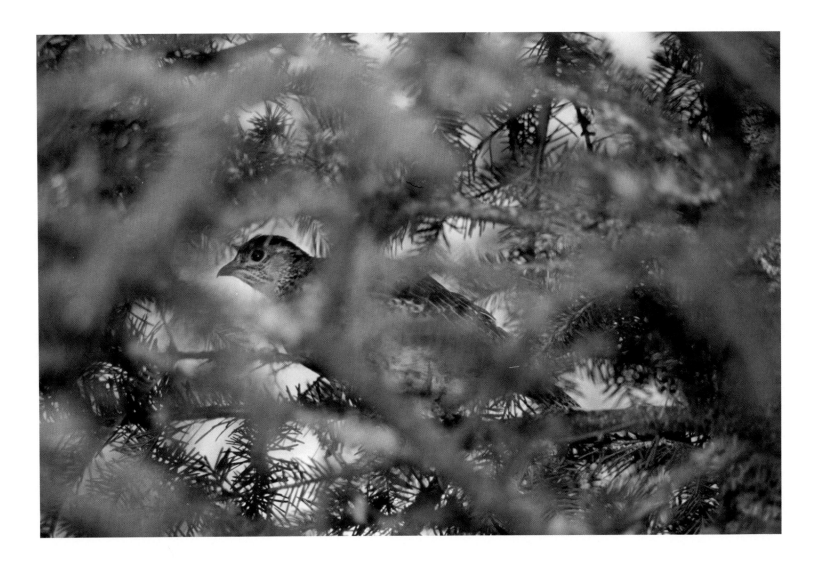

A young partridge in hiding.

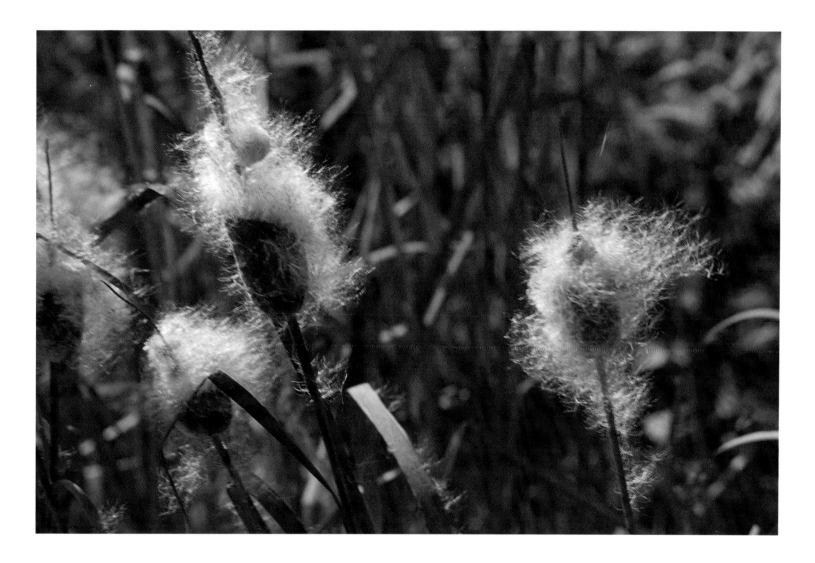

Cattails at their peak.

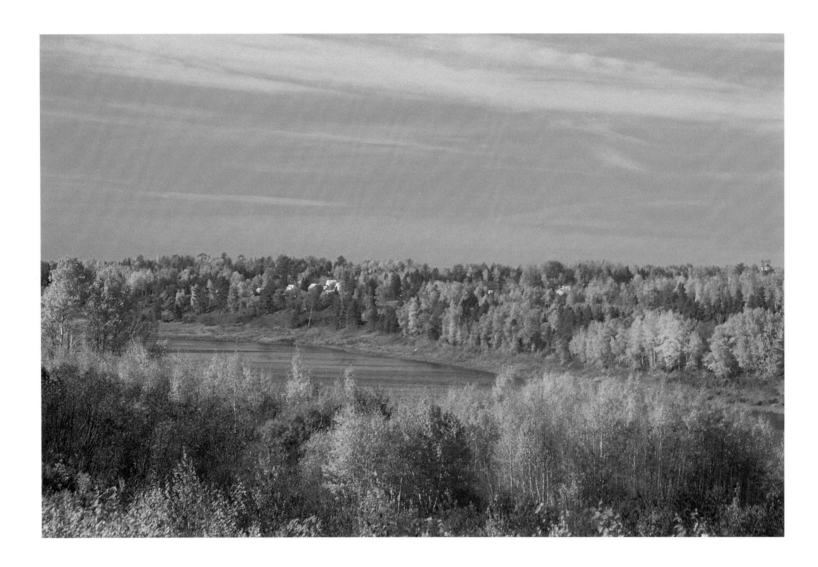

Southwest Miramichi splendour on Route 118 near Doyle's Brook.

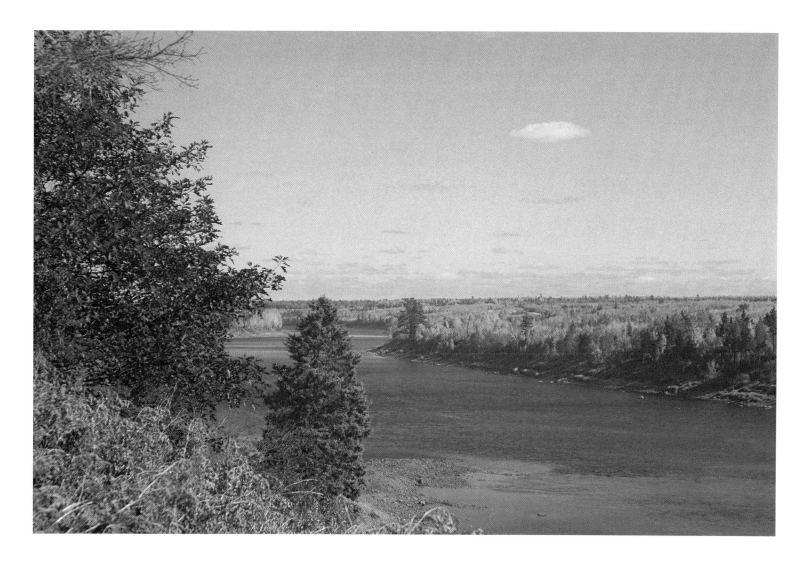

The Southwest Miramichi at Quarryville.

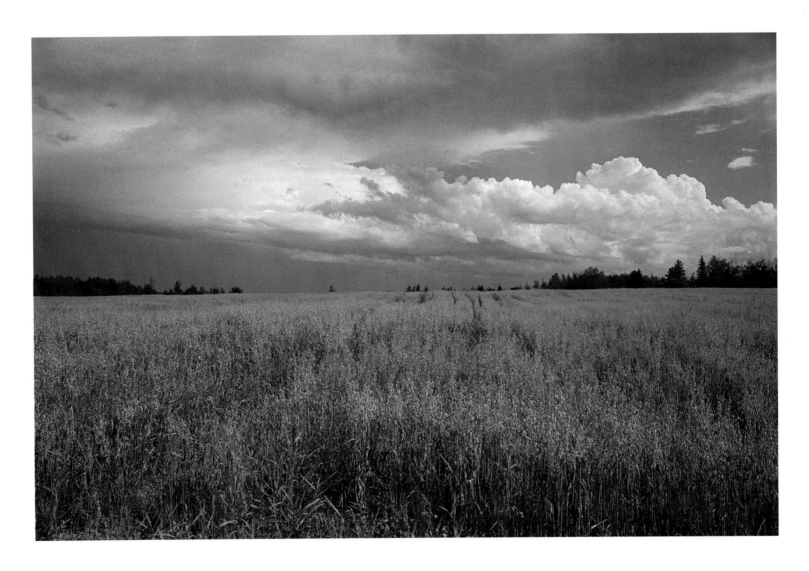

Oats ready for harvest in Nelson-Miramichi.

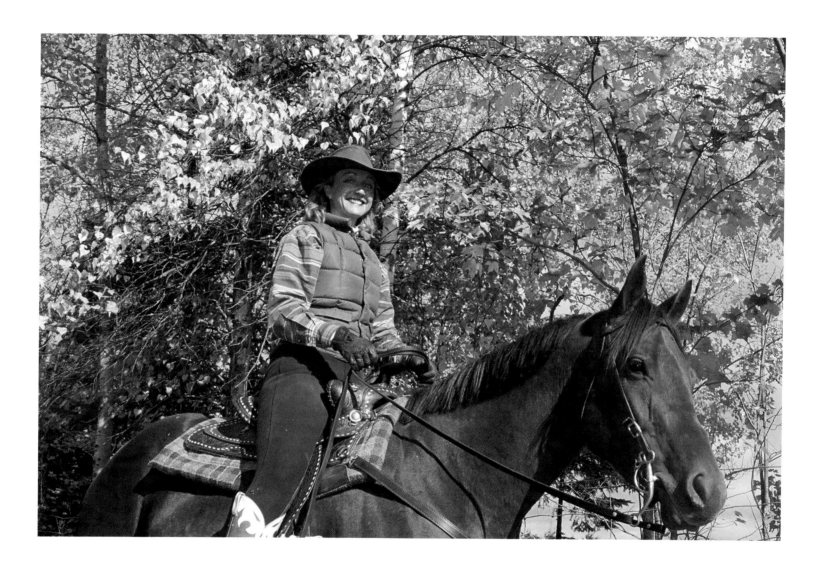

Equestrian instructor Evelyn Plaxton-MacDonald with horse Farrah at Lower Derby.

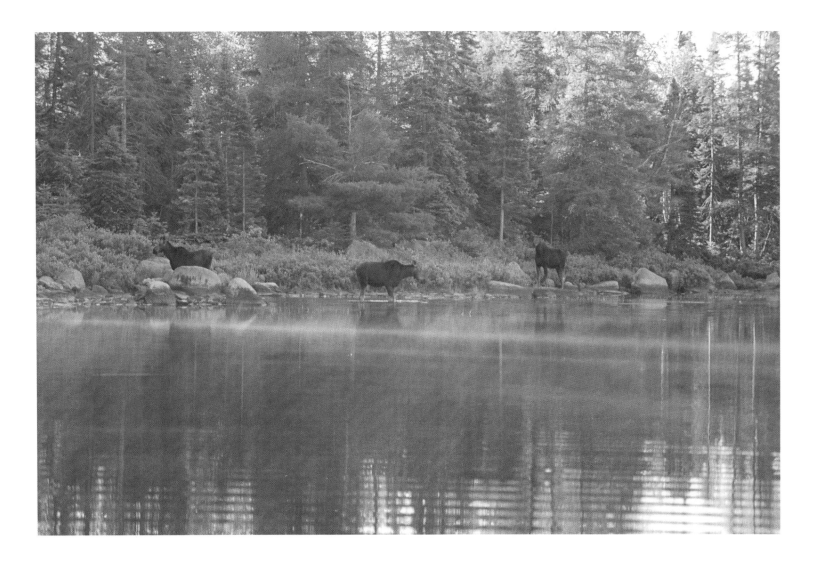

*Fog lifts off the silent waters as three moose appear along the stony lake shore (above),
while another takes a dip (opposite).*

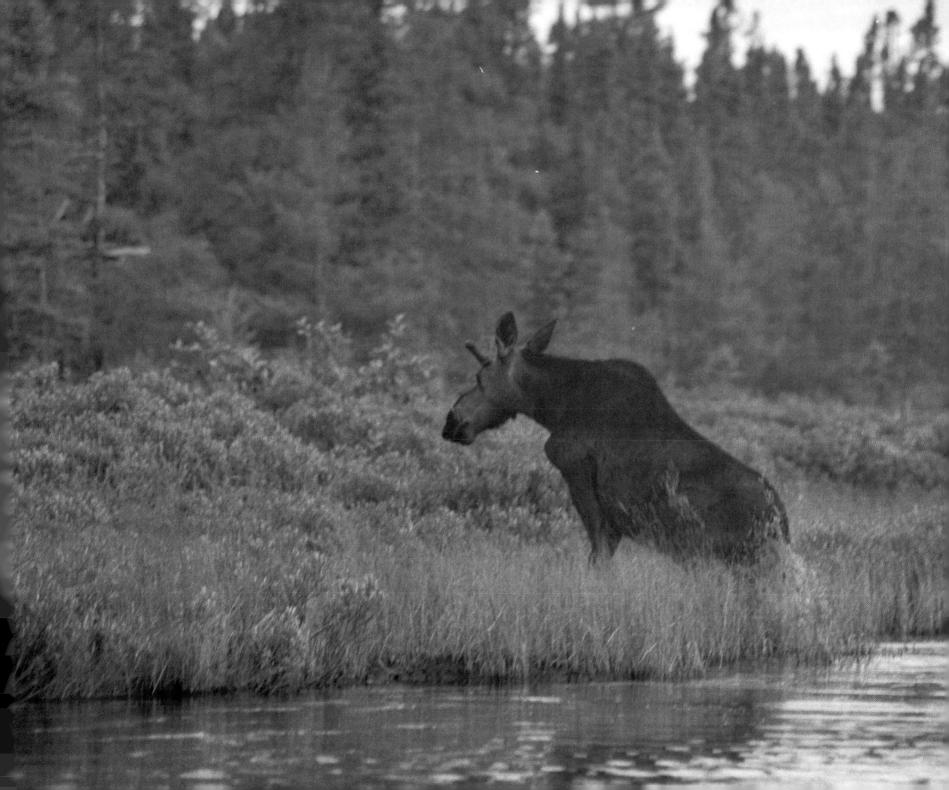

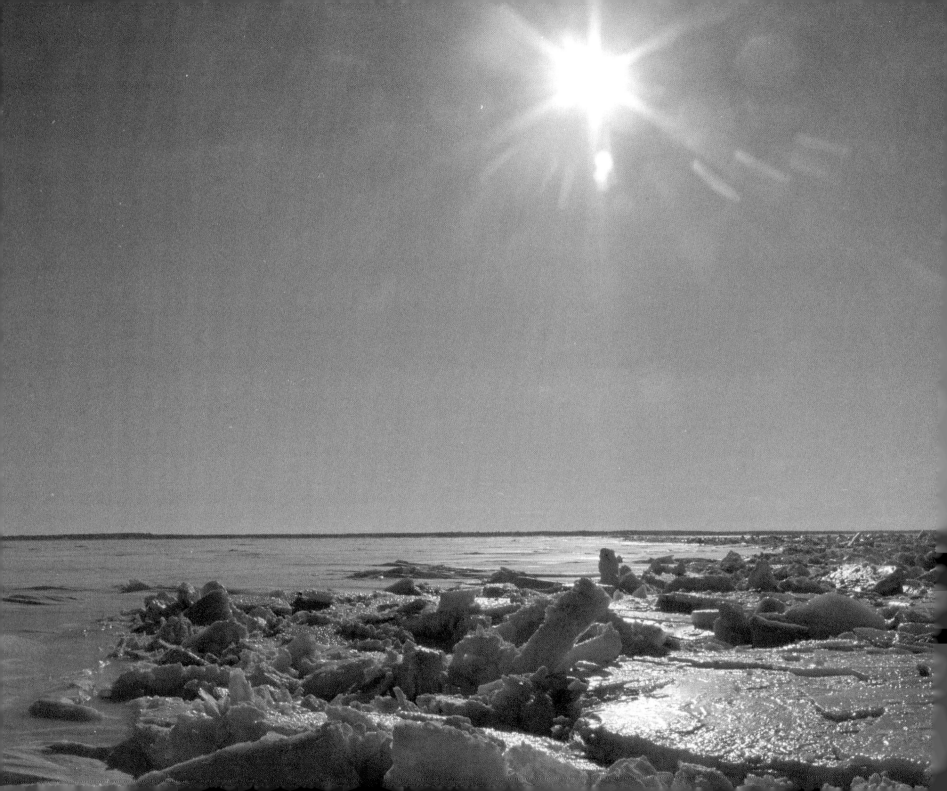

Winter

Old Man Winter arrives faithfully every year bringing with him a suitcase full of surprises. The Miramichi becomes a winter wonderland. Go walking, skiing, snowshoeing, skating or snowmobiling. Take a sleigh ride, or just sit and savour the season of white. Embrace the magic of youth as white snowflakes splash on your face. Hear the hush after a storm.

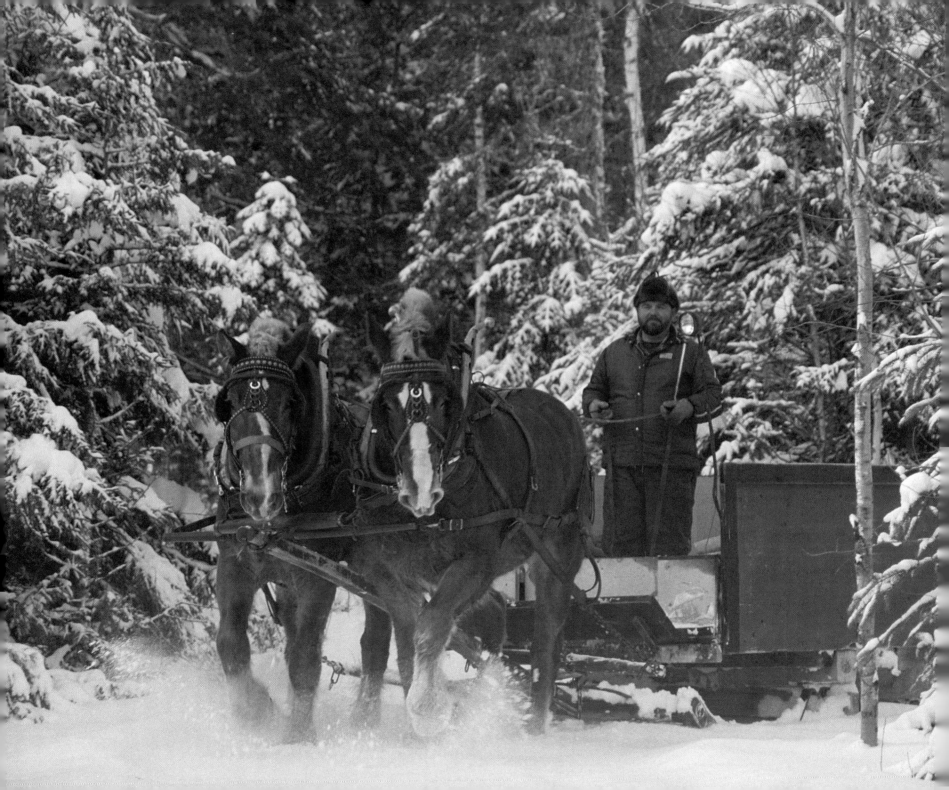

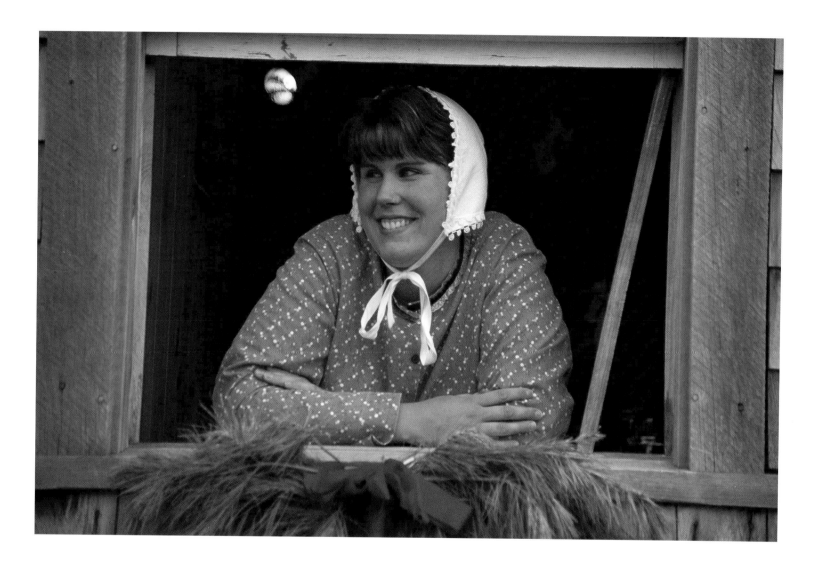

Nicole Gilks at the Doak Historic Site in Doaktown (above);
Murray Sherrard and his team at Boom Road (opposite).

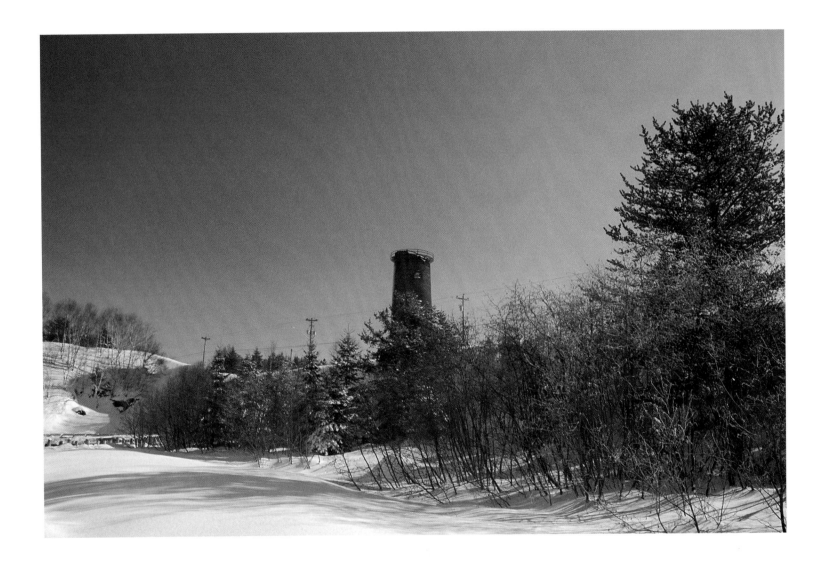

French Fort Cove.

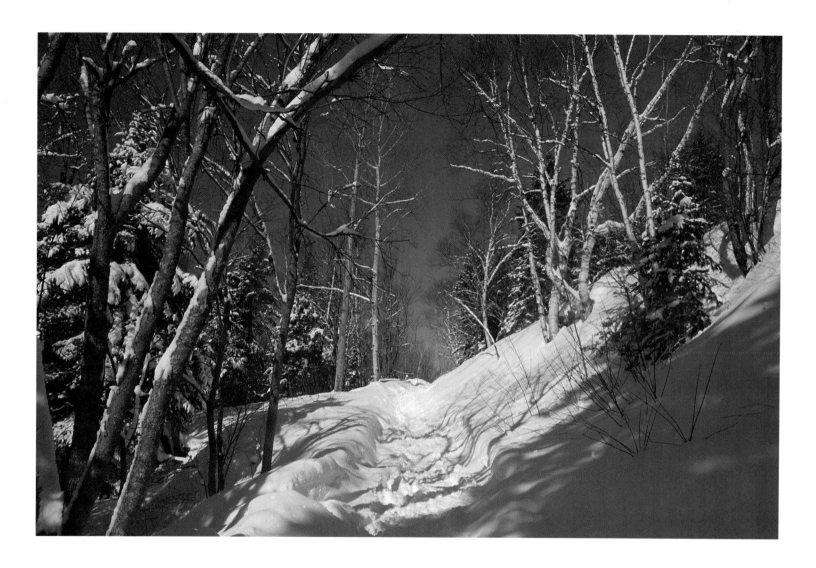

Winter trails at French Fort Cove.

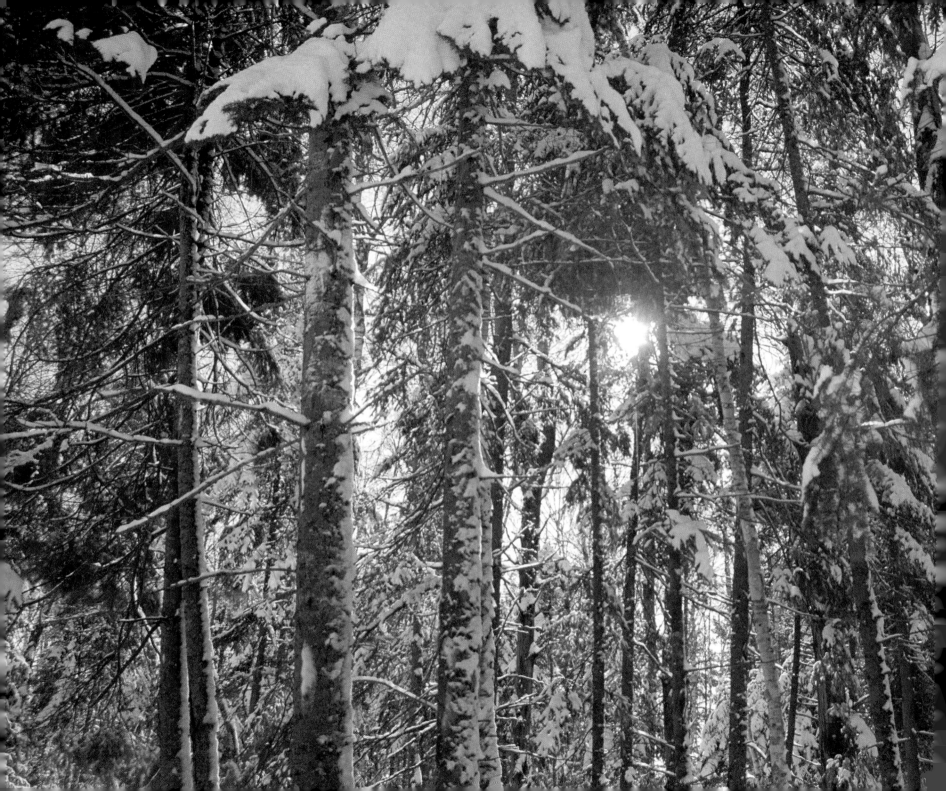

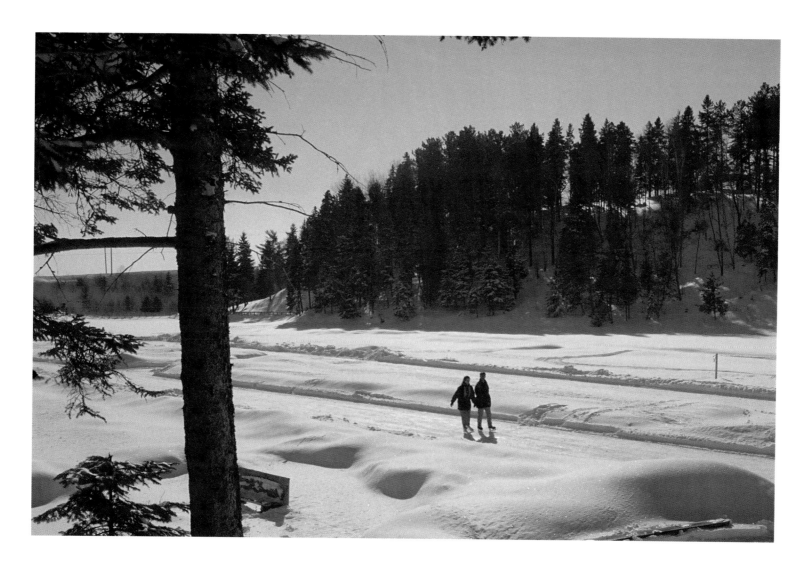

Skating at French Fort Cove (above); French Fort Cove (opposite).

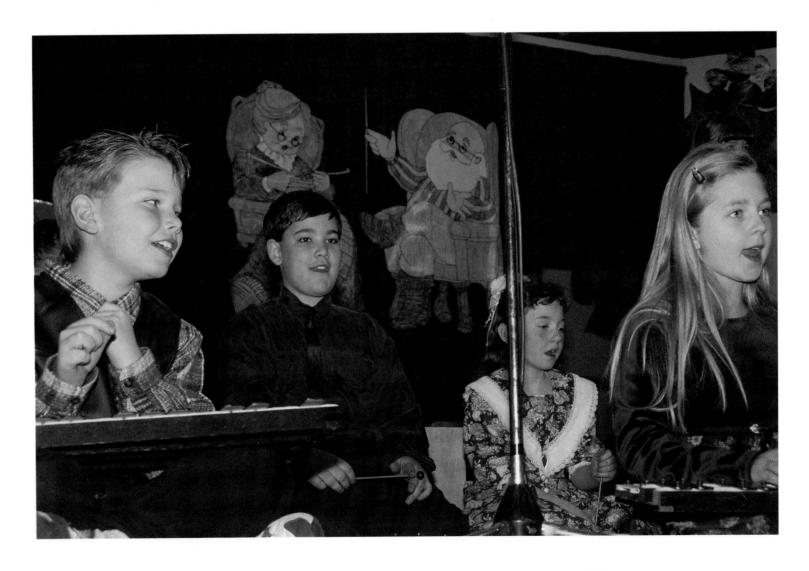

North and South Esk Elementary School students in Sunny Corner performing at the annual Christmas concert.
Left to right: Colby Waye, Justin McGregor, Brittany Lavoie, Jordan Allison (above);
Williamstown United Church (opposite).

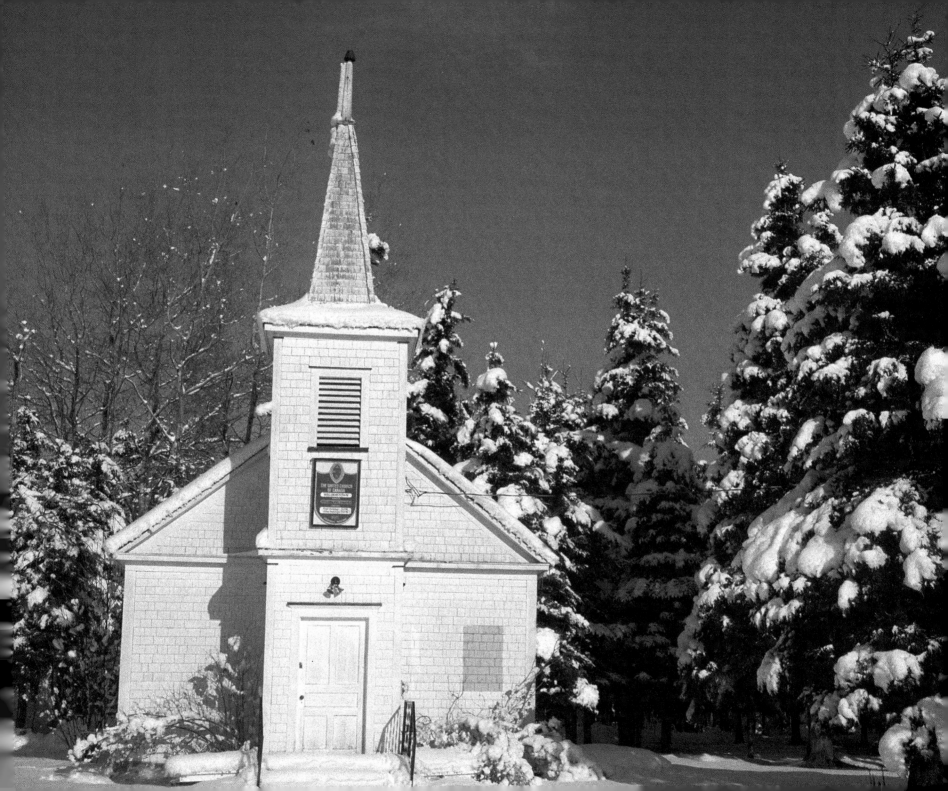

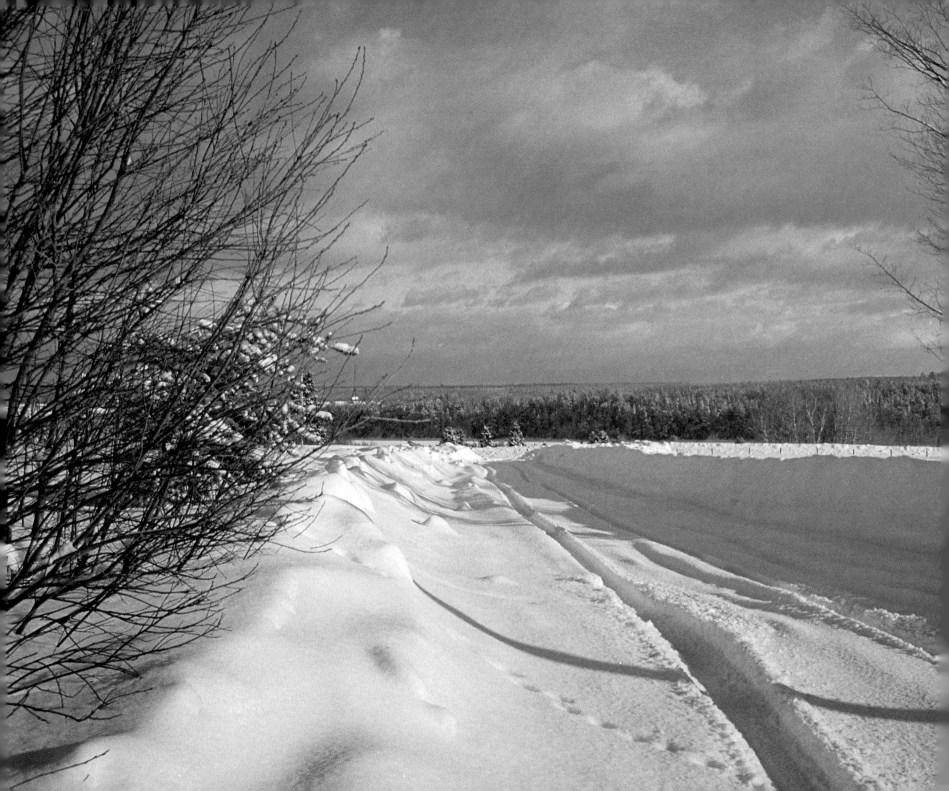

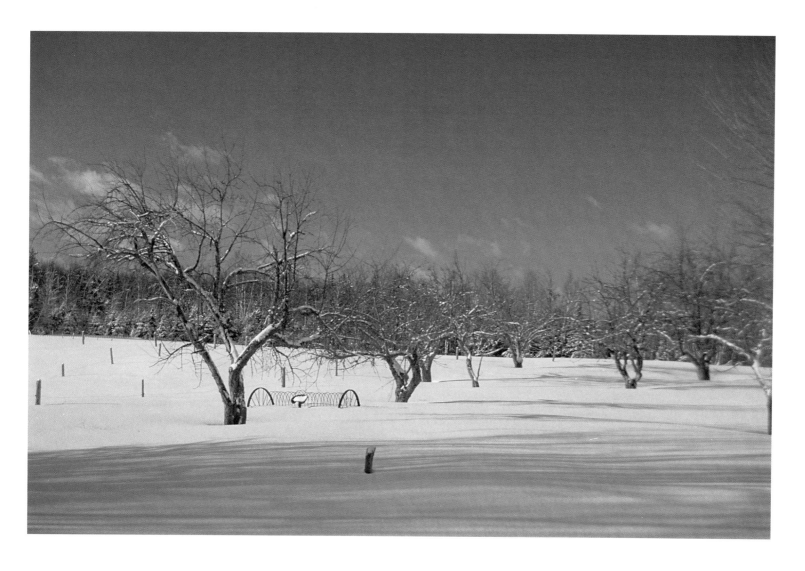

Edgewood Farm's frozen orchard (above) and lane (opposite) at South Esk.

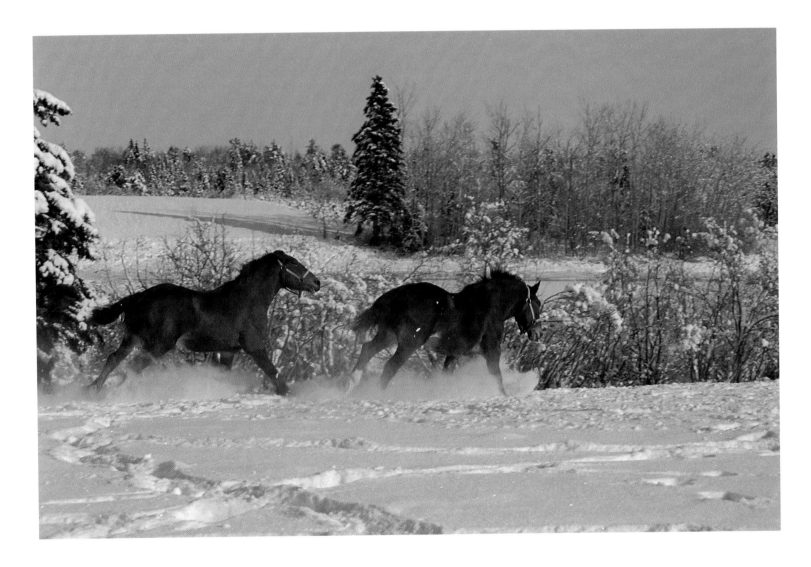

Lorne Harding's team of draft horses play a game of tag in their Tabusintac pasture.

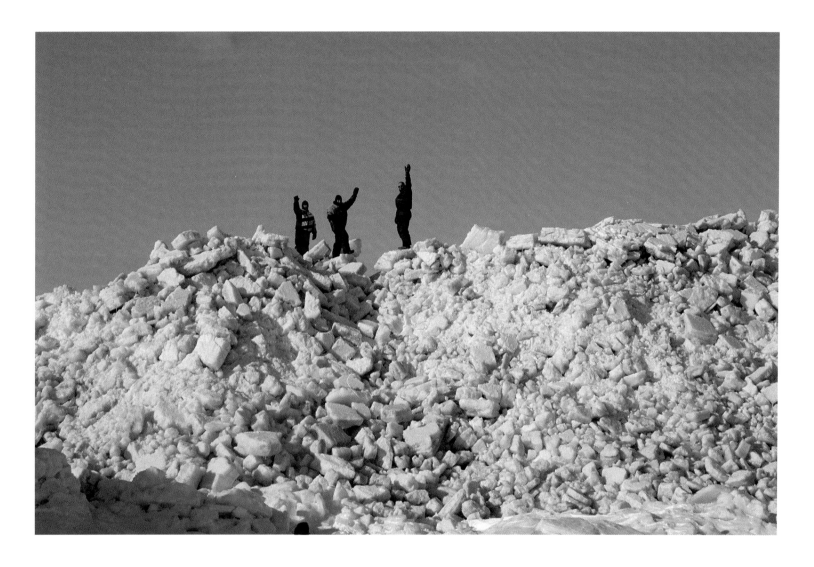

*Baie Sainte-Anne fishermen Charles Lirette, Abel Lirette, and Adrien McIntyre send greetings
from a pile of ice over 40 feet high at Fox Island.*

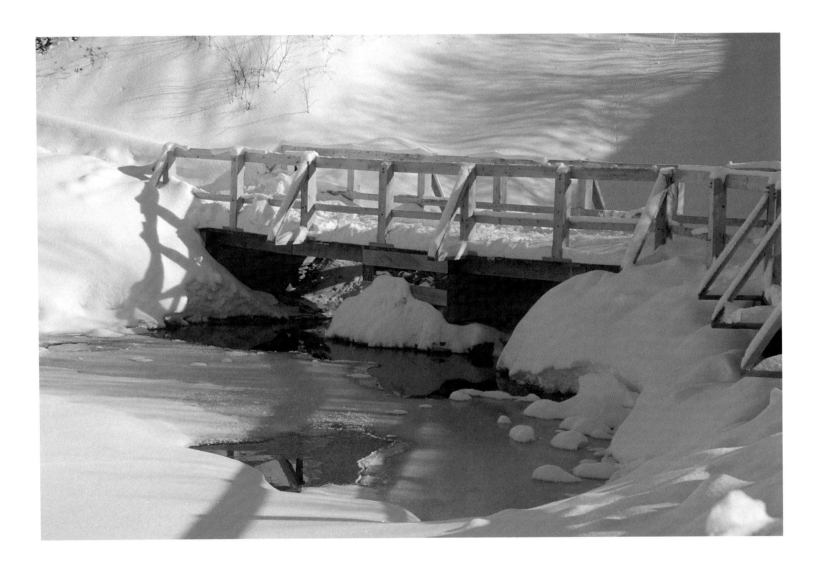

Water under the bridge at French Fort Cove.

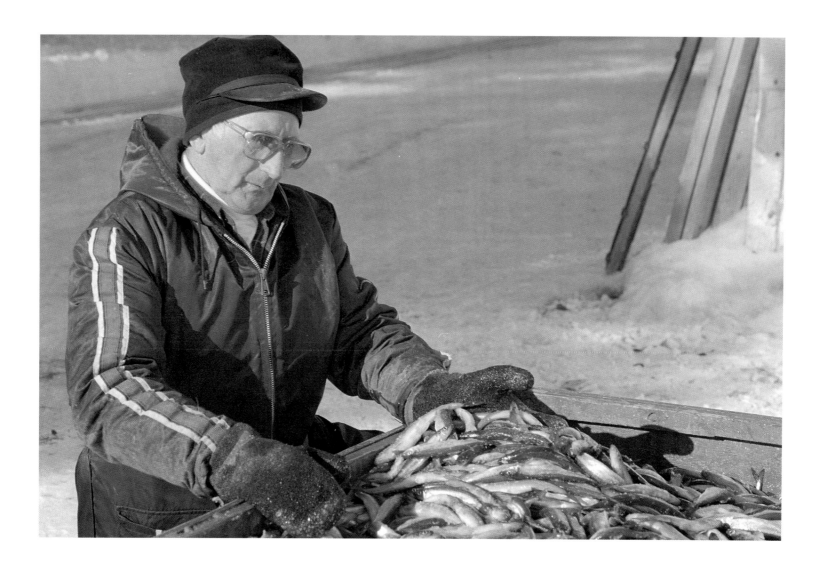

Smelt fisherman Theodore Williston of Hardwicke with a good catch.

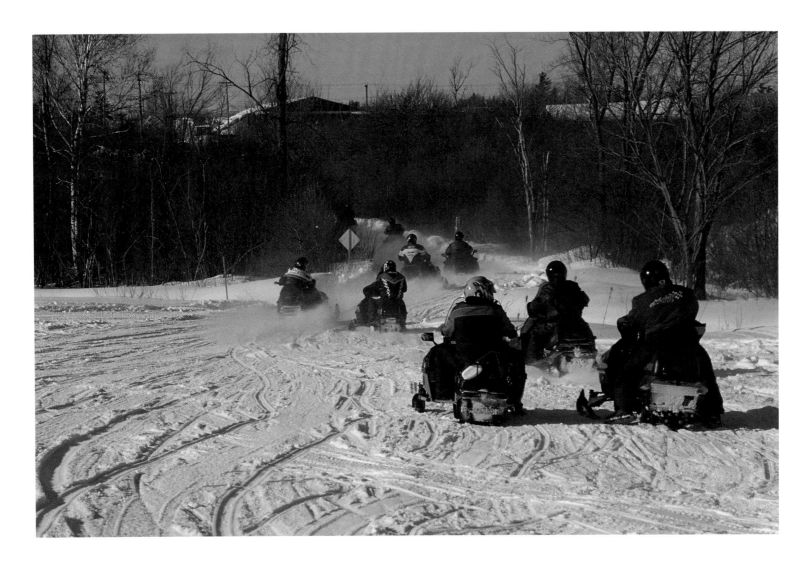

Snowmobiling is a favourite winter sport in Miramichi with groomed trails linking this area to all parts of New Brunswick.

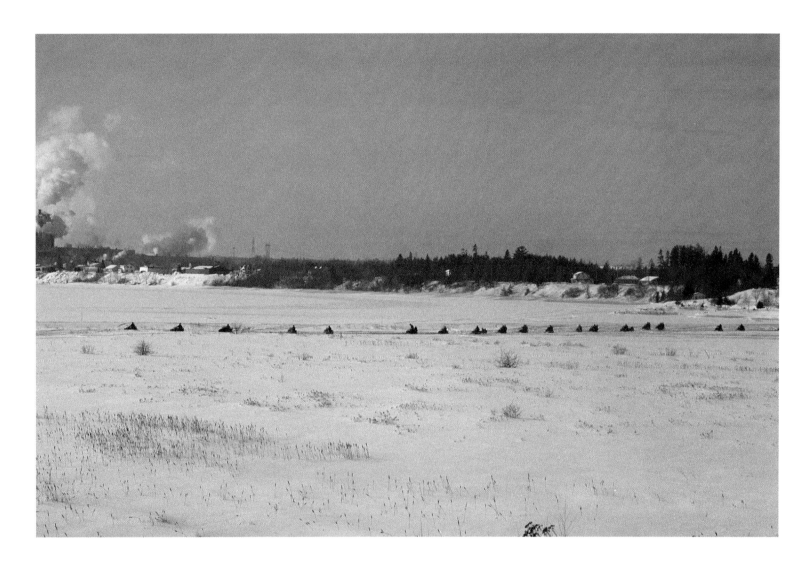

Snowmobile parade across Strawberry Marsh in Miramichi West.

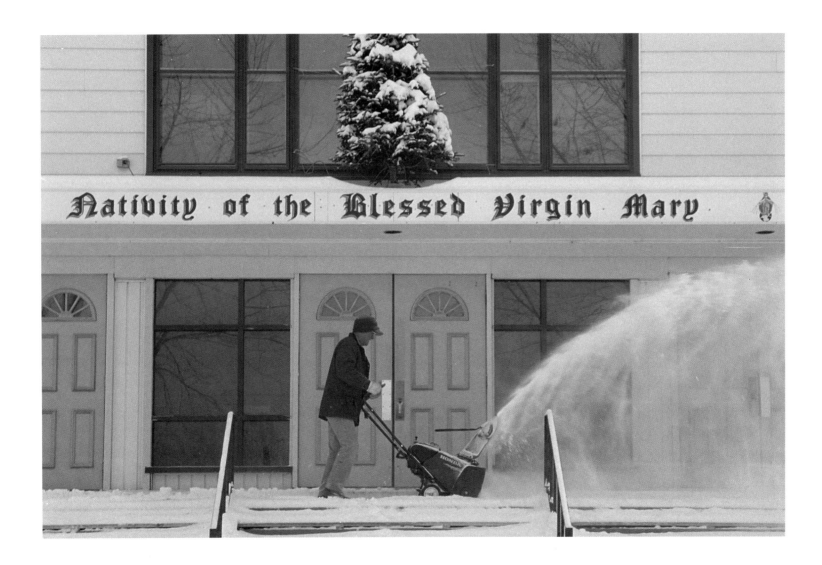

Edgar Comeau snowblowing at the Nativity of the Blessed Virgin Mary in Chatham Head.

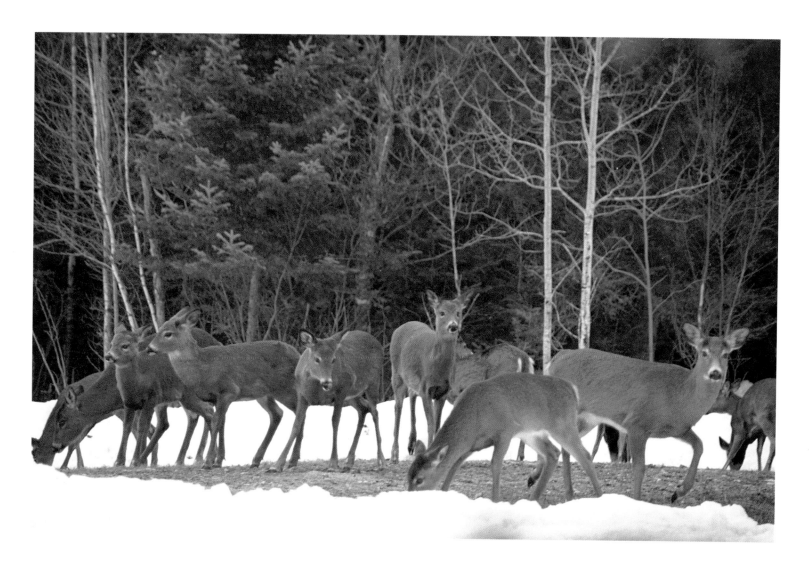

*Wes Hare and some neighbors in Strathadam befriend wild white-tails each year with sweet grain.
The deer cautiously gather at the field's edge in the evening.*

Acknowledgements

I always dreamed of writing books, but I never imagined that my first two would be of photographs. *Miramichi Magic* was a huge success and sold out in less than two months. My publisher was pleasantly surprised and decided, rather than do a second printing, we'd produce a second book. *Miramichi Seasons* is the result.

This photographic celebration of Miramichi is a reality because several Miramichi ambassadors who endorsed the first book also supported this one. I am extremely grateful to Bremner Farms Ltd. owner Leon Bremner; the City of Miramichi; Eagle Forest Products managing director John Godfrey; Eel Ground entrepreneur Roger Augustine; and Sky Park Miramichi Inc. general manager Rupert Bernard for their dedication to the Miramichi and for their gracious help.

I also appreciate the continuing support of CFAN Radio; Cadogan Publishing Ltd.; Metepenagiag School; M. Roy Innes Ltd.; New Brunswick Community College-Miramichi; and the Miramichi Agricultural Exhibition Association.

Tech Sea Corporation Ltd. is a welcome new supporter and I would be remiss not to give Frank's Holiday Resort at Chelmsford special recognition for its commitment to *Miramichi Seasons*. German businessman Frank Werner and his staff are introducing people from around the world to our little piece of Miramichi paradise.

— Cathy Carnahan